Günter Richter / Peter K. Burian
Nikon N50/F50

Günter Richter / Peter K. Burian

Nikon
N50
F50

Laterna magica

Magic Lantern Guide to
Nikon N50/F50

A Laterna magica® book

Third printing 1998
Published in the United States of America by
Silver Pixel Press
Division of
The Saunders Group
21 Jet View Drive
Rochester, NY 14624

From the German edition Nikon F50 by Günter Richter
Edited by Peter K. Burian
Translated by Hayley Ohlig
Editorial Assistant - Mimi Netzel
Production Coordinator - Marti Saltzman

Printed in Germany by Kösel GmbH, Kempten

ISBN 1-883403-13-8

Contents

Forward

The second camera to incorporate Nikon's latest generation of technology is the user-friendly N50, designated as the F50 outside the U.S.A. Although bearing little resemblance to its more traditional predecessors, this is definitely a Nikon in terms of versatility and value. Its sculpted, flowing lines combine functionality, ergonomics and elegance.

Nikon's claims for the N50/F50 are certainly appropriate. *"Shortcut to Great Pictures"* defines this camera, which is loaded with powerful technology but simpler to operate than most of its competitors. In fact, a mere four page operation manual teaches the beginner all of the camera's basic automatic modes. You may be wondering by now, "if it's really that simple, why do I need an entire book when anyone can take great pictures at the touch of a button?"

This is a valid question worth exploring before moving on. As technology has developed over the years, we have arrived at a dilemma common with many electronic devices. In principle, they require little user involvement. And yet, active participation in the process definitely produces better results than with reliance on a fully automated approach. Any tool is only as good as its operator. A chisel does not a carpenter make, and a camera - no matter how "intelligent" does not necessarily make a photographer either.

While a point-and-shoot approach can produce some decent pictures for your family album, "decision free photography" will achieve little more. Locking autofocus on the most suitable point, or selecting the right mode to depict the scene as desired, requires not only an intentional step but also an understanding of the results it will produce. At first glance, the N50/F50 looks like an "automatic camera". However, it includes a broad variety of modes plus most of the necessary overrides. Its modest exterior hides a highly controllable camera, ready to respond to your specific demands.

The instruction manual can tell you which buttons to push but not how to achieve beautiful pictures by exercising some creativity. We have written this guide with the assumption that you do

not intend to compete with professional photographers shooting for *National Geographic* or an international news service. Presumably, your goals are one of the following: you want to pursue photography as a hobby or to capture memories, travel scenes and family events without tedious calculations. And yet, you want to have pictures that are as good as possible - clear, bright, sharp and exactly mirroring you intentions.

It is precisely these goals that this guide will help you to achieve. First, it should demonstrate how to get the most our of your N50/F50 without getting bogged down in technical trivia. In addition, it should describe the essential concepts of photography and how specific effects can be achieved with the N50/F50. A guide to photography should not over complicate the process, but rather demystify the concepts so they can be understood by anyone with a grasp of a few basic principles.

Only by relating the N50/F50 to real world situations can the individual functions be fully explained. After all, we don't want to discuss buttons and switches but rather what these devices can help to achieve.

The first part of this guide deals with operating procedure, preparing to shoot, and fully automatic photography in SIMPLE mode. Before we move on to a full utilization of the camera in ADVANCED mode, a few concepts on which photography is based will be reviewed. Ease of understanding for the uninitiated will be our primary goal throughout this book as we help you to maximize the return on your investment in Nikon equipment.

A significant portion of the discussions are taken up by the N50/F50's exposure modes. We will then take you into the field of flash photography as well as the use of compatible Nikkor lenses. After all, what is a camera without a variety of lenses or focal lengths built into a zoom? And finally, we'll share our experiences in making better pictures. We'll move beyond the handful of practical tips to the third dimension of creativity.

Hopefully, you will have better pictures to show as a result of this manual, and our love of photography and appreciation for fine equipment will shine through even in the technical sections. Photography is far more than pressing buttons in the right sequence; so we wish you lots of fun and plenty of extraordinary light as you begin to explore the possibilities with this versatile Nikon camera.

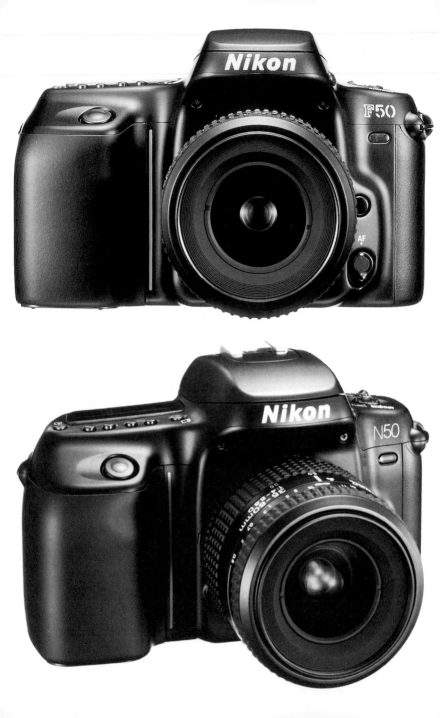

Introducing the N50/F50

Advances in micro chip technology have made cameras more and more versatile as a vast array of functions have been packed into even the most compact body. Frankly, it has also made operation of some models more complicated. As every invention was crammed into the latest marvels, they became victims of an excess of controls.

Some sported a myriad of buttons and dials which frustrated even the computer whiz who wanted to take pictures on weekends. Adding to the confusion, one often had to remember which two to press while turning another. No wonder then that many felt overwhelmed by these black wonder boxes that required constant reference to the instruction manual.

It took several years to convince the engineers to design more user-friendly models. Granted, some cameras are still a long way from this goal. Thankfully, the Nikon N50/F50 has received the benefit of enlightened thinking: a recognition that we are photographers and not computer programmers.

Its unique operating sequence was designed to make the many functions easier to understand and access. After working extensively with this camera, we congratulate Nikon on its achievements. The N50/F50 can truly be used without constant reference to a road map for charting your way through a maze of complex controls.

Although not loaded with every feature possible, the N50/F50 still includes all the essentials, from intelligent automation to many overrides. Hence, it's a bridge between the point-and-shoot compact 35mm camera and the most advanced models with additional features demanded by those specializing in certain types of photography.

The beginner can use the N50/F50 like a point-and-shoot camera, concentrating on taking better pictures instead of fiddling with numerous controls. As his photographic skill and experience expand, so does the camera. The N50/F50 allows for experimentation with the more demanding areas of photography and offers compatibility with the extensive line of autofocus Nikkor lenses and many accessories.

The N50/F50 benefits from Nikon's Advanced Matrix Metering which provides beautiful exposures with flash or ambient light or a combination of both. Thus, it is a serious contender even in the mid-range camera category, some of which cost twice as much.

The N50/F50 can be differentiated from many others in its price class by its construction. While Nikon, too, uses many poly-carbonate components, this model is heavier than some of the competition. That's because of a greater use of metal in essential areas (such as the lens mount) for greater longevity. Although a bantam weight in comparison to the upscale N90/F90, for instance, the N50/F50 remains true to the Nikon tradition of reliability and precision.

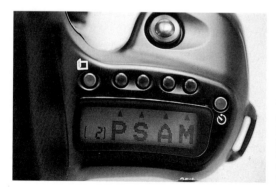

The dot-matrix symbols and letters in the LCD panel of the N50/F50 are clear and easy to decipher.

A New Operating Concept

In our opinion, a pre requisite to straightforward camera opera-
tion is logic. In other words, controls must be logically placed,
logically designed, and clearly marked. And the N50/F50 follows
a very consistent logic path, indeed. Once understood, all func-
tions and operations can be accessed quickly. Become familiar
with the operating sequence and the meaning of the symbols on
the external display panel and you're off and shooting.

At First Glance

Like most cameras today, the N50/F50 offers a liquid crystal dis-
play (LCD) which shows pertinent numbers, such as the shutter
speed. However, Nikon has gone a step further than any other
manufacturer, displaying many of the messages with dot matrix
symbols. These "icons" illustrate operating concepts in a format
most anyone can understand.

Pick up the camera and you'll note six buttons clustered
around the panel. The four located above the displays are
unmarked. These will be used to select various modes, with full
guidance provided by the displays. Another, to the left, is the
menu key, identified by a pictogram of an open book with a page
flipping. And the last is the self-timer control, marked with a uni-
versal clock symbol. Each of these will be described shortly.

Logical Operation

In order to demonstrate the logic of operation, let's switch the
N50/F50 to **ADVANCED** mode for a few minutes. When it is
turned on, the mode and settings that were used last are called up
on the screen. If you wish to change it, simply press the menu
key and the following four basic functions are displayed:

P	S	A	M

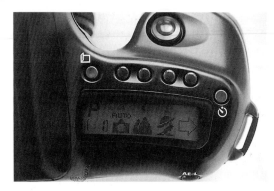

Press the Menu button (with open book symbol) to call up the second screen of function options: General Purpose, Landscape, and Portrait Program. The arrow indicates that you can flip to the next "page" from this screen.

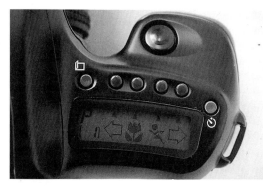

From this screen you can select Close-Up and Sport Program or flip to the next or previous "page" (screen).

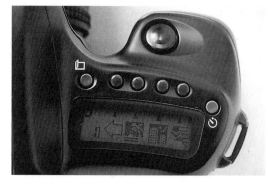

The last screen in ADVANCED mode, offers Silhouette, Night Scene and Motion Effect Programs. From here you can only flip to a previous "page" (screen) of functions as denoted by the single wide arrow.

These mean Program, Shutter Priority, Aperture Priority, and Manual mode respectively. We'll discuss each of these in detail in a subsequent chapter. An arrow appears above each letter pointing to the button located directly above it. Pressing one of these results in the selection of the corresponding function; for example, press the first to select Program mode.

Program Options
Do so and the camera displays several options on the LCD panel. The first is "AUTO" mode - where all settings are made by the system. But you are given two other options here: **Landscape Program** (denoted by an icon of a mountain), and **Portrait Program** (by a face). Want more? Then note the large arrow on the right end of the display. Its message means: "If you want more programs, press the button above this arrow".

Now two additional subject program icons appear: **Close-up** (denoted with a flower) and **Sport** (with a runner). But there are also two large arrows at each end, one pointing to the left and the other to the right. Think of these as page flippers in a restaurant menu. The arrow pointing to the left signifies "go back to the previous page". The one pointing to the right means "go on to the next page".

Let's do the latter, making the next three subject Programs appear. The first is **Silhouette** (denoted with a palm tree at sunset); the next is **Night Scene** (by buildings at night); the last is **Motion Effect** (denoted by a runner with streaks).

A single arrow, pointing to the left, indicates that you can only go back to the previous page from here. You have reached the end of the options.

Note: Remember that for now, we're just experimenting. This is necessary to start getting an appreciation for the logic of the operating sequence. Don't worry yet about the particular relevance of any program. We'll review each of these later. To conserve battery power, the display disappears after eight seconds. Touch the large shutter release button (trigger) gently at any time and the symbols re-appear.

Other Options
Pressing the menu button (open book symbol) returns us to the first "page" again, with the P, S, A, M possibilities. This time press

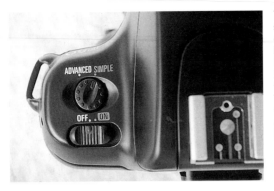

The main switch, which can be operated by feel, is located on the left shoulder of the camera. The mode selector (for SIMPLE or ADVANCED) is above it.

another button: "S" for **Shutter-Priority** mode, "A" for **Aperture-Priority** mode, or "M" fully **Manual** mode. Now, only the parameter that needs to be set appears in the external screen. In "S" for example, the shutter speed appears, in "A" the aperture (denoted with an f/number), in "M" both appear. The arrows demonstrate which buttons to push to raise or lower the displayed values. And that is all there is to it.

Well, *almost* all there is. If you press the menu button a second time, the so-called Functions Menu appears. Additional settings can be controlled here: film speed (ISO), autofocus mode, and exposure compensation. We'll cover these later, but the important point is this: every function of the N50/F50 follows exactly the same logic as described above. Because of this consistency, even the advanced features are not difficult to find and select.

Additional Operating Controls

There are few other controls on the N50/F50. The self-timer (used for a ten second delay) is perfect for triggering a tripod-mounted camera without vibration or for getting into the picture yourself. There is also the Manual Focus/Autofocus switch and the (unmarked) lens release button. On top of the handgrip is the trigger (shutter release button), angled for comfort.

Though neatly hidden, there's a built-in flash head which pops up at a touch of the button on the left side of the Nikon logo. If flash is not desired, simply pop it back into place. The "hot shoe" on the top of the camera has four electronic contact points,

Besides the four buttons which select the function displayed in the LCD panel, there are three others, "Menu" (top left), Self-timer (right) and AE-L: "Auto-Exposure Lock" (back).

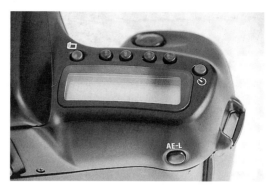

The self-timer LED (which flashes during countdown), the white lens alignment mark, the lens release button and the focus mode switch are located to the left of the lens.

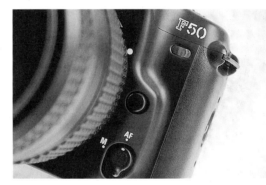

The built-in flash unit is elevated by pressing an unmarked button on the left side of the prism housing. Flash is automatically activated when the flash is raised.

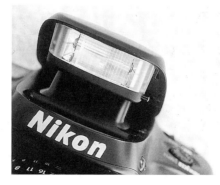

The built-in flash head is ideal for use in low light, when the subject is reasonably close to the camera.

allowing the N50/F50 to communicate with an accessory speed-light when one is mounted. In addition to greater power for distant subjects, these offer additional features discussed later.

The final control is a button marked AE-L, at the right rear corner of the body where your thumb naturally comes to rest. This is the Auto Exposure Lock, which will hold an exposure reading while recomposing. With this you can optimize exposure for a fisherman instead of the brilliant lake surface, for example.

The Reflex Viewfinder

One of the many advantages of a camera like the N50/F50 is that you view directly through the lens which will take the picture. There is no need for a secondary lens to the top (or side) of the "taking lens". Hence, you can more accurately see what will be included in the picture, which is especially critical with close-ups.

The viewing screen of the N50/F50 is quite bright and contrasty - a joy to work with for anyone accustomed to an older camera. You'll notice a fine circle etched on the screen with two rectangular brackets in the center. The latter indicate the AF sensor field. Cover the desired subject with the brackets to ensure that it will be in focus (instead of the background). The circle denotes the area which is given primary emphasis by the center weighted light meter. The N50/F50 automatically switches into this metering pattern when manual exposure (M) is selected.

The viewfinder area corresponds to approximately 90% of the image area. In other words, you see only 90% of what will actually be recorded on the film. This makes sense for two reasons. First, a full 100% image coverage would have increased the camera's weight and price. Secondly, very few photos ever show everything recorded on the negative or slide. Some of it is "lost" - cropped off when a print is made or covered by the slide mount.

Eyeglass wearers will appreciate the viewfinder design. The entire image (and displays below) can be seen from a distance of 18mm from the eye-piece. Thus, there's no need to remove corrective lenses when taking pictures.

The Viewfinder Display

Look through the finder while in SIMPLE mode and absolutely nothing interferes with your viewing. Not even the shutter speed or aperture (f/number) displays distract your eye. Switch to ADVANCED mode, and that essential information is now provided below the image area. And if you have set additional overrides, a symbol acts as a useful reminder.

In SIMPLE mode, only a black dot (confirming focus) and a circle (indicating correct exposure) are visible. If flash is required, a blinking lightning bolt symbol appears; once flash is activated, it stops blinking.

In ADVANCED mode, the amount of feedback increases sub-

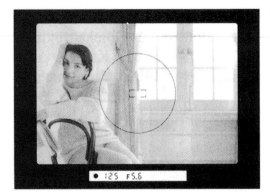

Etched onto the viewing screen are a pair of brackets that represent the autofocus sensor area and a circle representing the 75% center-weighted metering area (in M mode only).

stantially. Besides the aperture and shutter speed, a "+/-" symbol appears as a reminder if an exposure correction value has been input. In fully manual operation, a scale appears: denoting any deviation from the camera recommended exposure values. This makes working in manual highly convenient.

Memory Function

If you usually shoot with a certain exposure method or subject program, it can be stored in ADVANCED mode. This is how it's done:
1. Press the menu button (marked with an open book) twice. The first symbol in the series is an [M] inside an open book. This is the Memory Selection function.
2. Press the button above the [M]. The PSAM series appears again.
3. Select the desired exposure function by pressing a button. Let's say you want to select Portrait Program. In that case, press the button above the P. When the next screen appears, press the button above the symbol of a face.
4. Lock in your preferred setting by pressing the button over the selected program or function. The camera then switches back to the last used setting.

By pressing the "M" button to the right of the page icon, any desired exposure function can be stored in memory for later recall instantly.

The stored function can be called up by pressing the menu key for about two seconds. The memory can be erased by repeating steps 1 and 2 above and pressing the button over the [C]. The [C] turns back into an [M], indicating that the memory has been eliminated.

This is perhaps the most complex operating sequence of the entire list of possibilities. Many others will seem simple in comparison. In our estimation, it is only a nicety, far from essential. Still, it can come in handy if you frequently want to return to a certain mode at the touch of a single button.

The Panic Button

On occasion, you may become confused by the settings stored in memory or other user-selected options such as exposure compensation. This is the time to reset the camera to the General Purpose Program.

If you have not used the memory function or the exposure compensation option (described later), press the menu key (open book) for three seconds to reset the N50/F50. The word AUTO above a camera symbol confirms that all customized settings have been erased.

If you have used the memory feature or exposure compensation, the reset method differs. In this case, press and hold both the menu and self-timer buttons simultaneously for about three seconds. This returns the N50/F50 to all factory selected settings. Should you forget this sequence, removing the battery - with the camera set to "OFF" - for a few seconds accomplishes exactly the same thing.

Getting Ready to Shoot

It's time to get down to the first order of business, which is to prepare the N50/F50 to shoot a test roll. There are only a few tasks here, and most of them need be done only the first time the camera is turned on. After that, you need only remove the lens cap, turn the camera on, load a roll of film and select a desired mode.

The Power Source

The N50/F50 uses a single 6 volt lithium cell, commonly designated as a 2CR5 type, or DL245 in some brands. According to Nikon specs, this cell should power the camera for about a hundred 24 exposure rolls of film at 68° F (20° C) without flash. If the built-in flash is used about 50% of the time, this number drops to about 20 rolls.

Lithium batteries are more expensive than their alkaline counterparts, but offer several advantages: lesser weight/size, quicker flash recycling, and longer life, especially at low temperatures. Even at 14° F, one 2CR5 will power the camera for 40 rolls; if the pop up flash is used 50% of the time, this is reduced to 13 rolls.

Note: The above estimates are optimistic, as with every camera we have ever used. That's because the test conditions cannot be duplicated in "real world" photography. Then, too, several variables come into play: the amount of autofocusing, the time spent with your finger on the trigger, the amount of flash power expended in any situation, etc. Consequently, the number of rolls per fresh battery will differ from one photographer to the next and from one set of circumstances to another.

Loading the Battery
Before installing a battery, set the main switch to OFF. Open the compartment cover in the bottom of the hand grip. Slide the bat-

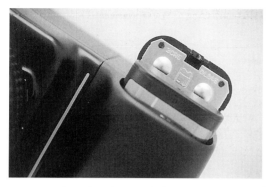

A 6v lithium battery is inserted into the compartment with the contact points first.

tery into the chamber with its contact points first. This is just about foolproof unless you insert the battery upside down. In that case, the camera will not be activated.

Now flip the main switch to ON and the N50/F50 is ready to shoot. The external panel will show a frame number, or "E" for "empty" until film is loaded.

If a half-full battery symbol blinks in the LCD panel, the battery is already weak. A blinking "Err" and an empty battery symbol means the power source is practically dead. If the panel remains blank, the battery is exhausted or was inserted incorrectly.

Note: Because a 2CR5 lithium cell is not as universally available as alkaline AA's, always carry a spare when travelling.

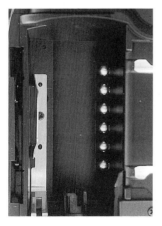

When the camera back is open, six contact points are visible in the film chamber. These read the DX codes on film cartridges to set ISO (film speed) automatically. Avoid touching the contacts.

The Camera Interior

When you open the back by pressing the release latch, you will see six silver contact points on the left side of the film compartment. These allow the camera to read the DX coding on the film cartridge. The checker board pattern holds information on film speed, length, etc. which is automatically transferred to the camera's computers. Avoid touching these contacts.

In any event, the interior of the camera deserves great care. The highly sensitive shutter curtains, for example, can easily be damaged with one slip of the thumb. As one of the authors (PKB) discovered after an unhappy experience, replacement of the shutter mechanism can be very expensive.

Loading the Film

In comparison to older cameras, loading film is a pleasure. The chore is almost totally automated, much to the joy of most photographers. Before putting the roll in the camera, pull the leader a little further out of the cartridge. If you do this afterwards, you run the risk of inadvertently touching the shutter curtains. (If you pull the film out too far, you can easily push or wind it back a little.)

Insert the film cartridge with the protruding axle downward, onto the spring loaded receiver; then clip it in at the top. The film leader has to reach precisely to the red line on the opposite side.

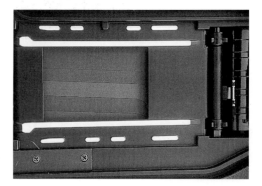

Care should be taken not to touch the sensitive shutter blades under any circumstances!

When it is nice and smooth, close the back by pressing lightly The camera then transports the film to the first frame - even when it is switched off.

After the film has been loaded, check the frame counter! If it shows "E" (for empty), the loading mechanism did not grab the film. In that case, open the back again and pull the film out exactly to the mark.

Checking or Modifying Film Speed

As long as you are using a DX coded film between ISO 25 and 5000, the N50/F50 automatically sets the film speed. Want to double check that the setting has been made correctly? Then switch the camera to the ADVANCED Mode and press the menu button (open book symbol) twice. Press the button above the "ISO" (film speed) symbol and a readout will appear displaying the ISO value.

The speed and code of the loaded film can be seen through a small window in the camera back.

You cannot override the pre-selected value! If the film cartridge has a DX code, the camera will automatically set the correct film speed. Some photographers shooting color slide or black and white (b&w) film will occasionally decide to shoot at a film speed other than the standard ISO - later compensating for the deviation in processing.

Hint: There is a trick that can be used to fool the camera into believing the loaded film is not DX coded. Simply cover the bar

codes on the film cartridge with a sticker or masking tape. You can now set the desired ISO number by pressing the button above the ISO symbol. This is only possible in ADVANCED mode, of course.

Film Transport and Rewind
If you have been working with an older camera - without motorized film drive - the N50/F50 will be a pleasure to use. It automatically advances the film to the next frame after each exposure. This takes about one second so that it is ready to take another shot as soon as you have removed your finger from the trigger. The ability to advance film without removing the camera from eye level is often appreciated.

At the end of the roll, the camera automatically switches into rewind mode. After rewinding, "E" will appear briefly in the LCD panel and the film roll symbol will flash. You can now open the back and remove it, with the top end first. Should the N50/F50 prematurely stop rewinding because of cold or a low battery do not open the back! The unprotected part of the film would be destroyed by light!

Hint: If the "E" does not appear, rewind has stopped in mid-roll. Do NOT open the back. Turn the camera off to give the battery a "rest" in a moderately warm spot. Later, with the camera ON, press the rewind button on the base of the body. If it fails to restart, you'll need to buy a new battery immediately.

Switching Film Mid Roll
As with most cameras today, the film leader is drawn all the way back into the cartridge after rewinding. This is a safety precaution to prevent the same film from being loaded and exposed for a second time. But what if you want to change films in mid roll? For example, you may want to switch to an ISO 400 film to shoot an auto race after taking candid portraits of the drivers with ISO 100 film.

Removing a partly exposed roll (at the tenth frame, for instance) is simple enough. Press the rewind button on the base of the N50/F50 to start the process.

As with many cameras, the challenge arises later when you want to reload the original roll. The film leader must be retrieved in order to do so. If you're near a One Hour lab, the staff can do so

Press the recessed button on the base of the camera with a pointed object (such as a pen) to commence rewind of a partly exposed roll of film.

for you. Out in the field, however, you'll need a device called a "film leader retriever", available from a well stocked photo retailer.

Hint: Before rewinding in mid-roll, check the frame counter on the LCD panel. Write the frame number on a strip of masking tape and stick it on the original roll of partly exposed film. Later, when you reload it, select the smallest aperture (often f/22) and the highest shutter speed (1/2000s) in manual mode "M". Set the autofocus switch to MF as well. *With the lens cap on and the viewfinder window covered,* press the trigger until the desired frame number is reached. Always go one frame further as a safety precaution to avoid overlapping images.

Mounting and Removing the Lens

To mount an AF Nikkor lens, turn the camera off and remove the body cap and the lens' rear cap. Leave the front cap on to avoid getting a fingerprint on the front element. Next, align the lens' orienting mark - usually a white or colored line - with the white dot on the left front of the body.

Hold the N50/F50 in your left hand <u>with the lens pointing upward</u>. Turn it to the right until it locks. Do not press any button on the camera body while doing so.

To remove the lens, hold the camera in your left hand, with the lens pointing upward. With your left thumb, depress the lens release button on the camera body. Now turn the lens to the left in order to unscrew and remove it.

The lens bayonets onto the stainless steel mount and locks into position when rotated. Press the unmarked release button to unlock the lens in order to remove it.

Lens Protection Tips

Avoid touching the contact points at the rear of the lens barrel, and keep them clean with a gentle rub of a soft cotton cloth. Put the rear cap on immediately to protect the electronic contacts and mechanical lever. When setting a lens down, stand it on the front element covered with a cap.

If you plan to carry the N50/F50 without a lens attached, purchase a Nikon body cap. This rigid black plastic cap screws into the bayonet mount and stays solidly in place. The translucent white cover that came with the camera falls off much too easily.

Final Preparations

We still have two remaining tasks before shooting. First, the aperture ring on the AF Nikkor lens must be set for the largest f/number: usually f/16, f/22 or f/32 depending on the particular lens. *This is essential because the camera will not operate with the ring at any other position.* Once set, lock it in by sliding the small switch located at the far right of the aperture ring.

Forget to do so and the letters **"Err"** will appear in the viewfinder and on the external panel. An aperture symbol with the word "min" will also blink in the external panel.

Finally, check the AF/MF switch on the front left of the body. Set it for "AF" if you plan to shoot with autofocus, although you

AF Nikkor lenses have a small sliding switch (above f/4, here) used for locking the ring to the minimum aperture (smallest opening/largest f/number). This is mandatory with the N50/F50 as f/stops are selected electronically at the touch of a button and not mechanically with the aperture ring.

may prefer manual focus for some situations. Given the highly reliable AF system of the N50/F50, autofocus will be your usual choice for the vast majority of subjects.

Practicing the Right Stance

No matter how advanced the N50/F50's computerized systems, sharp pictures require a steady grip. Holding the camera in an ineffectual manner will often lead to disappointing results. To maximize the chances of a sharp picture, try the following.

Hold the grip with a relaxed right hand and rest the index finger gently on the trigger. When taking a picture, additional *gentle* pressure should be used. Jabbing the button will almost certainly produce motion blur as the camera will not remain steady. Maintain constant contact with the trigger, increasing it slightly to take the picture. This tactic alone can sometimes make the difference between sharp and unsharp images.

Stand in front of a mirror to practice the right stance. Cradle the lens in your left hand for additional support. Encircle the barrel with the left thumb and index finger. Press the camera gently against your forehead while looking through the viewfinder. Try

the sharpshooter's trick: exhale and hold your breath when pressing the shutter release.

More importantly, *tuck your elbows in to your sides* and spread your legs apart in a comfortable stance. This creates a human tripod, affording the most rigid support possible while shooting with the camera handheld. For a vertical composition, your right elbow may be in the air (depending on the direction the camera is rotated), but keep the other one tucked in. If possible, find some firm external support: rest your elbows on a table, lean against a door frame, or use the roof of a car for greater stability.

To get the maximum value from your fine Nikkor optics, remain conscious of the shutter speed. For handheld work, it should be "at least one over the reciprocal of the focal length". This means 1/60s with a 50mm lens, 1/250s with a 200mm telephoto, and 1/500s or higher with a 300mm or longer lens. High shutter speeds are possible with a faster film such as ISO 400. Otherwise use flash or one of the hints provided above to prevent camera shake.

Shooting in "SIMPLE" Mode

The First Step

The N50/F50 comes with a four page sheet explaining everything you need to know to begin taking good pictures. While ADVANCED mode calls for extra pages of instruction, SIMPLE mode is a suitable starting point for those first moving up from a point and shoot camera.

Nikon bills the N50/F50 as *"powerful technology with simple operation: your shortcut to great pictures"*. While we would not want to be restricted to the few options in SIMPLE mode, it does offer a choice of a General Purpose Program plus three subject-specific programs. These are fine for those who appreciate the N50/F50 as a means to producing technically good pictures before acquiring photographic skills.

Functions in SIMPLE Mode

Turn on the camera and switch the selector dial to SIMPLE for your first outing. Only a film frame number and the camera symbol plus the word "AUTO" should appear on the LCD panel. If you see others, reset the camera by pressing the menu button (denoted with an open book symbol) for three seconds.

If a blinking camera symbol also appears, the light level is too low for handheld photography without flash. For this exercise, switch to an ISO 400 film or move to a brighter location.

In General Purpose Program, the camera automatically selects the appropriate aperture and shutter speed for accurate exposure. The exact combination - depending on the light level - is not displayed anywhere. This avoids confusing the novice and may not be particularly relevant at this point.

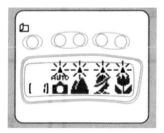

The Multi Purpose Program is ideal for quick shooting when getting the picture is more important than the settings.

All you need to do is enclose the most important part of the scene in the square brackets on the focusing screen. Light pressure on the trigger activates the autofocus (AF) and auto exposure systems. At this stage, the primary subject should be in the center of the screen until focus is achieved. Although the AF sensor is in the middle of the screen, there is absolutely no need to use it like a bull's eye.

Not every picture should be framed with the subject in the dead center. After finding focus, maintain light pressure on the trigger and change the composition as desired. Focus will remain locked.

The Four Primary Programs

The "AUTO" mode is engineered to produce "good" results in many situations. In order to tailor the settings more precisely to the most popular subjects, SIMPLE mode offers two subject-spe-

cific programs: Landscape and Portrait. To select one, press the menu button (open book icon) when the camera is on. All four program symbols - in dot matrix - appear in the LCD panel. Select the one desired by pressing the button above it.

The settings which are selected by these programs will be discussed in the Chapter on ADVANCED mode. We don't need to concern ourselves with technical factors just yet.

The Built-in Flash

Activating the Flash

When the lightning bolt symbol in the viewfinder blinks, the camera is suggesting that flash be used for the best results. So press the little button beside the "Nikon" logo and the built-in flash unit will pop up.

The N50/F50's Matrix Balanced Fill-Flash computer takes care of mixing available (ambient) light and flash light to obtain an even illumination. This helps prevent a bright subject against a murky background as is common with some less sophisticated systems. Just the right amount of flash is fired automatically for a pleasing overall rendition.

The built-in auto flash is also appropriate in bright sunlight. The additional lighting helps soften harsh shadows, such as those cast by a hat over a child's face. And in backlighting (with the sun behind the subject) it helps reduce the excessive contrast, evening the brightness level of the subject and background.

Maximizing the Flash Range

The retractable flash head was never intended to replace the high power accessory speedlights. Because its power is relatively low, it is useless beyond a few yards. Shoot the bride and groom at the front of the church some 30' away (with ISO 100 film), for instance, and they will be under-exposed when you get your prints back.

At ISO 100, the little built-in flash manages to reach only around 10' indoors, although its exact range depends on the conditions. Switch to a "faster" (more sensitive) film if you frequently use the retractable head. With an ISO 200 film, for example, its reach increases to 16' in typical conditions.

This data is really only applicable when the flash provides most of the illumination by itself. If used in daylight, the range extends a bit further. Even a tiny spark of light will brighten shadows or add a catchlight to your subject's eyes without overpowering the ambient light.

Warning Symbols

Even in SIMPLE mode, certain warning symbols can appear. These can be frustrating unless you understand exactly what they mean and how to solve the problem.

The "HI" warning: In extremely bright light (especially with an ISO 400 film) you may get a "HI" warning. In this case, the camera is not offering a greeting but a warning: the subject will be overexposed because of an overabundance of light which must be reduced.

Hint: Most of us carry a polarizing filter - typically used to darken blue skies - made of a gray glass. This also helps to cut the amount of light entering the lens, which is often adequate to solve the problem. Switching to a slower speed film (such as ISO 100) will usually do the trick too, but it's a lot of effort for only a few pictures. If possible, ask your subject to move into the shade and the "HI" warning should disappear.

The "LO" warning: In the opposite case, when it is so dark that available light no longer suffices for a good picture, the N50/F50 will blink "LO" in the viewfinder. Clearly, the situation calls for flash. Remember the restricted range of the built-in flash; use an accessory speedlight for distant subjects. As an alternative, switch to a fast film (perhaps ISO 1600) if planning to shoot in a museum or other location where the use of flash is prohibited.

The Lightning Bolt: There's another important warning provided by the N50/F50 in flash photography. After you take the picture, keep an eye on the lightning bolt symbol in the viewfinder. If it blinks nervously for a few seconds, it is warning that the output of the flash head may not have been adequate. Your photo finisher

may be able to make an acceptable print from the underexposed negative. But for better results, try again from a closer vantage point or use a high power accessory speedlight instead.

Autofocus Hints

At other times a black dot will blink in the viewfinder panel and the lens will rack back and forth seeking focus. This is a clear signal that the autofocus system is struggling with the subject. The AF sensors need some kind of contrast or pattern, or a vertical line, as a reliable target for autofocus.

With a plain wall or the featureless sky, autofocus simply will not work. One option in such a situation is to locate an object at the same distance. Focus on a door frame or a distant tree instead. Then change your composition with light pressure on the trigger. This will hold focus until the picture is taken. You could also switch to manual focus by moving the lever on the front of the camera to MF.

When shooting a subject with horizontal lines (such as the horizon or venetian blinds) the AF system will also balk. That's because the sensors are sensitive primarily to vertical lines. No problem; merely turn the camera on an angle until focus is achieved. Then, recompose with light pressure on the trigger.

Although extreme highlights (such as reflections) can frustrate the N50/F50, its autofocus is reliable, except in darkness. In such situations, your own eyes will not be reliable either. Add an accessory speedlight with its infrared light emitter - this will project a bright red pattern on the subject as a target for the AF sensor.

No technology is absolutely foolproof, but these tips should help to prevent frustration. In our tests, the N50/F50 proved successful with most common subject types; only the N90/F90 offered a noticeable edge in AF performance. With race cars, for example, the latter definitely proved more capable, but the N50/F50 was able to track all but the fastest action. Suffice it to say that Nikon incorporates time-tested AF technology in this camera. Hence, it will offer fine performance in most situations, with manual focus available as a useful backup when all else fails.

Basic Concepts of Photography

Until now, we have treated photography as little more than a process that entails pressing a couple of buttons. But that is only the beginning. Before moving on to taking demanding shots or exercising creative control, it is important to understand a few essential concepts. These are crucial for any photography beyond rudimentary snap shots.

Without overcomplicating the entire process, we'll explain some important relationships and terminology. These will help to illustrate the value of the many functions of the N50/F50 and how these can be used to translate your vision onto film.

N50/F50 vs. 35mm Compact Cameras

Comparing a point-and-shoot model to the N50/F50 is like comparing a Cessna to a jet plane. A primary difference is the ability to view the scene through the lens which is used to take the picture. There's no need for a second viewing lens above or beside it as with less sophisticated models.

The N50/F50 is an SLR, a single lens reflex camera. With this type, the light entering the lens reflects off a mirror onto the viewing screen. The image you see is the same as will be recorded on the film. (Hence the terms "reflex" and "single lens").

An SLR camera offers an ideal viewfinder since it shows exactly what the lens sees, whether it be a wide angle or super telephoto. This is a prerequisite when using one of today's popular zoom lenses. No matter how you zoom in or out, the image on the viewing screen will correspond to the image the film will record. Thus, you can effectively judge the framing and composition. However, with a compact 35mm camera, only those which incorporate a "zoom finder" (to match the focal lengths) provide a reasonably accurate view.

More importantly, the viewing screen of a single lens reflex camera shows the exact focus status. This is unlike a "rangefinder" camera whose secondary lens shows everything as

A Single Lens Reflex camera provides an accurate view of the subject as it is viewed through the single "taking" lens. A "reflex" mirror reflects the light up to the prism and the viewing screen.

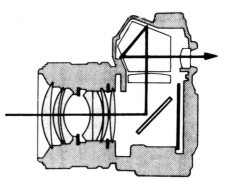

The mirror flips up (out of the light path) for the exposure and seals off light from above, also blocking your view of the subject. After the exposure, the mirror flips down and the viewfinder can be used as usual.

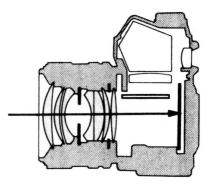

sharply rendered, whether focus was set for the subject or a distant background.

Note: Actually, as with most SLR's, the viewfinder shows a bit less than the image which will be recorded on film, as explained previously.

Superior Flash Control

Compact cameras can't hold a candle to SLR cameras in another respect: controlling flash output. Your N50/F50 does not have to rely on an external light reading sensor to estimate how much flash light is being reflected in order to determine the exposure. It meas-

ures flash illumination internally with a separate metering cell. And this provides superior exposure control because the reflected light reading is measured through the lens (TTL). With Nikon's highly capable Matrix Balanced Fill Flash technology, beautiful results are possible both outdoors and in dimly lit interiors.

Shutter Speed Control

The shutter mechanism of the N50/F50 offers electronically controlled speeds from 1/2000s to 30s. In Aperture Priority (A) and in Program modes, the scale is stepless. In other words, the system can select any exposure time: opening the shutter to expose the film for 1/279th of a second, for example. This provides the ultimate in fine tuning of exposure.

In Shutter Priority (S) and Manual (M) modes, speeds can be set in half-step increments, such as 1/350s. In this regard, this camera has an advantage over even the expensive N90/F90, which can be set only in full steps.

Shutter Speed Effects

With the N50/F50 the range of shutter speeds is vast, compared to even the most expensive compact 35mm cameras. The shutter speed is one of the factors which determines overall exposure, as it controls the length of time light is allowed to strike the film. Whether this is a full second or a mere 1/2000s will have a very different effect, as we'll see.

Naturally, this also determines the sharpness of the image, in many situations. If you expose for a full second, a handheld shot will be hopelessly blurred due to camera or subject movement. Even if a tripod is used, moving objects will appear blurred against a sharp background. (Such blur can be a creative effect however, if intended and well executed).

If, on the other hand, the exposure takes only 1/500s, the picture will be sharp. Unless you intentionally jerk the camera when pressing the trigger, or shoot a jet plane approaching at extreme speed, motion will be stopped or "frozen". Conversely, at 1/4s you can depict fluid motion, such as that of a waterfall cascading down a cliff or an athlete's limbs blurred by the speed of her motion.

The N50/F50 exposed this subject perfectly in the Multi Purpose Program with Advanced Matrix metering. (AF Nikkor 35-80mm f/4-5.6; Kodak Ektachrome film). ⇨

The N50/F50's Multi Purpose Program is ideal whenever you don't want to fiddle with controls or don't have time to do so. The results are consistently good.

Right:
Multi Purpose Program selected a suitable aperture/shutter speed combination for this scene. Advanced Matrix metering achieved a very good balance between light and shadow.

Below:
The bright surroundings did not confuse the Advanced 3D Matrix system in the least. The whites remain clean and pure, while the dark tones are correctly rendered as well. Override of the camera-selected exposure was unnecessary. (Aperture Priority mode, at f/13 and 1/90s, with the lens against a window pane to avoid reflections and to stabilize the equipment).

All pictures taken with the AF Nikkor 35-80mm f/4-5.6D on Kodak Ektachrome film.

⇧

Nikon's Advanced 3D Matrix metering managed to produce a pleasing rendition here without any exposure compensation.
(AF Nikkor 80-200mm f/2.8 D and SB-25, Kodak Ektapress ISO 1600 film).

Even candid portraits benefit from a longer focal length (a 70-210mm or ⇨ 80-200mm zoom is ideal). The Portrait Program produces a pleasing out of focus effect in the background. This emphasizes the subject and blurs away distracting elements. (Kodak Ektachrome film).

⇦ Preceding double page:
This situation which could have been designed specifically for the Night Scene Program with a bit of fill flash from an SB-25 flash. The exposure is ideal again, thanks to Advanced Matrix Metering. The brightening effect of flash is really only noticeable to the trained observer.
(AF Nikkor 28-70mm f/3.5-4.5D, Kodak Ektar 400).

Aperture Control

Unlike the point-and-shoot compacts, the N50/F50 allows for full control of the lens' aperture. Increasing or decreasing the size of the opening is another means of controlling the amount of light which will strike the film. Built into each lens is an iris diaphragm which allows the opening to be adjusted. This is referred to as "selecting an aperture", whose sizes are designated with f/numbers such as f/8. This concept is similar to the functioning of our eyes; the pupils also open and close depending on the amount of light.

Like the shutter, adjusting the aperture size can be used to control exposure by increasing or decreasing the flow of light. The shutter controls the length of time light is allowed to enter while the aperture controls the amount which can strike the film in any given time span. In this manner, the two control elements work together, complementing each other as we'll explain in greater detail shortly.

Demystifying f/stops

Long ago, someone decided that we needed reference values for the various sizes of openings. The following series of numbers, called f/stops, was developed: 1, 1.4, 2, 2.8, 4, 5.6, 8, 11, 16, 22, 32, 64. Ignore f/1 and f/64 as these are not available with any current Nikkor lens.

With any lens, f/1.4 is a wide aperture, and f/32 is minuscule in comparison. The size diminishes gradually as you work your way up the scale, so f/16 is smaller than f/5.6.

A typical landscape, but the conditions were not necessarily right for the Landscape Program. This picture was taken with a long focal length, so the program selected a wide aperture to assure a fast shutter speed (to prevent blur from camera shake). This is a suitable precaution for handheld photography but not for more serious pursuits which call for a tripod. At 200mm the camera-selected f/4 (at 1/180s) would not have provided adequate depth of field.

Switching to Aperture Priority mode is a suitable strategy when the Program does not select the best f/stop to achieve a specific effect. [With a wide angle lens however, the Landscape Program often makes suitable selections because the shutter speed required for handheld work need not be as high at 28mm (1/30s) as at 200mm (1/250s).] Hence, the system can select a smaller aperture for greater depth of field. (Kodak Ektachrome film).

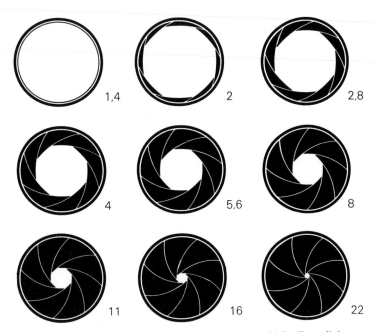

Changing the f/stop varies the size of the opening which allows light to enter. The higher the number, the smaller the opening.

In other words, higher numbers correspond to ever smaller openings. When we speak of a "wide aperture", we mean a large opening and small f-stop number such as f/2. This may be a little confusing at first. As soon as you become accustomed to associating f/stop and aperture size, the concept will become crystal clear.

Granted, this is one of those factors that most people find difficult to remember. We recommend drawing a rough chart showing a large circle at f/1.4, smaller at f/2 and so on... down to a very small circle at f/32. (You will find such a diagram in this guide, but draw your own as you'll want to add to it later).

To be more specific, these increments mean that the next number lets in half as much light and the previous number twice as much. So the circle at f/2 on your chart should be half as large as the one at f/1.4, and so on. A rough estimate is close enough for this purpose as long as it helps you to remember the concept.

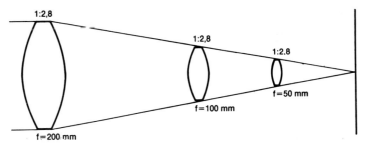

The longer the focal length, the larger the diameter of the aperture required for any given f/stop. Consequently, long lenses of wide maximum aperture will have a barrel of the widest diameter.

Shutter and Aperture Interaction

Although we did not specifically mention this earlier, each shutter speed is twice as long as the previous speed. Hence, 1/30s lets in twice the amount of light as 1/60s at any given aperture size. It follows then that 1/250s lets in half the amount of light as 1/125s, because the time span is half as long.

Again, note the doubling factor. This provides consistency of exposure control, whether controlled with the shutter speed or the aperture (f/stop). Note that 1/500s is twice as long as 1/1000s, or half as long as 1/250s with any camera. If this sounds backwards, think about it for a while, perhaps using 1 second versus 1/2 second and 1/4 second as examples.

So doubling the aperture size or doubling the time the shutter remains open produces the same effect in terms of exposure. In either case, the film receives twice as much light as before. By increasing or decreasing one or both of these variables, the photographer (or an automatic mode) controls exposure.

Note: The N50/F50 incorporates an "intelligent" light metering system (called Matrix) which ensures correct exposure. It will set (or recommend) the right combination of aperture and shutter speed to produce a nicely exposed picture in most circumstances.

Exposure Control Analogy
Perhaps the most useful means of clarifying this entire concept is to use the following analogy: Suppose we have a tap to which

several hoses are attached and we want to fill a child's swimming pool. With a hose of narrow (1/2") diameter it would take ten minutes. Switch to one of double the diameter (1") instead, and it will take half as long or 5 minutes.

In photography, we want to properly expose a frame of film. We can do that by controlling the diameter of the opening, or the amount of time the shutter remains open. Just as it takes x amount of water to fill the pool, it takes x amount of light to produce a nicely exposed picture. It doesn't matter which variable you control: the time light is allowed to flow, or the size of the opening through which it flows onto the film. (In truth, you could also adjust both - just as in the swimming pool analogy).

Understanding Lenses

Lens Speed Defined

We often hear photographers mention that they're saving to buy a "fast" lens. This simply means a lens with a wide maximum aperture, such as f/1.4 in a single focal length lens or f/2.8 in a zoom. The wider the aperture, the better you can stop motion without using flash. A large opening allows for a higher shutter speed to freeze camera shake or subject movement.

A glance at the lens specifications chart in a Nikon brochure demonstrates an interesting point. The longer the focal length, the larger the diaphragm required for the maximum aperture. Thus, the lens barrel (and optical elements) must be of greater physical diameter to accommodate the mechanism. This, in turn, increases the cost of such lenses. The recent drive to reduce the

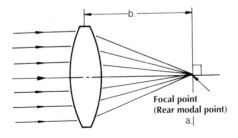

Focal point
(Rear modal point)
a.

Focal length, marked "b", is defined as the distance from the optical center of the lens to the rear nodal point when focused at infinity.

size/weight of zoom lenses was achieved through smaller maximum apertures, now common in every brand.

The N50/F50's "standard lens," the variable aperture AF 35-80mm f/4-5.6 D, offers a modest f/4 at the wide angle end, diminishing to a mere f/5.6 as you zoom toward 80mm. For high shutter speeds, lenses like this often require a faster film. The more sensitive ISO 200 for example, requires only half the light needed for proper exposure with its ISO 100 counterpart. Since today's ISO 200 and 400 films produce excellent 8x12" enlargements, we see less need these days for expensive "fast" lenses. That's because these "fast" films help achieve the desired effect even with affordable "slow" lenses, those of modest maximum aperture.

Comparing Focal Lengths

Just as one cannot progress in photography without understanding the terms aperture (or f/stop) and shutter speed, an appreciation of lens characteristics is helpful. Without getting into technical jargon about focal length, all you really need to know for now is this: a 200mm lens covers only half the area of a 100mm lens because it provides twice the magnification. (Actually, doubling any focal length achieves roughly the same effect).

The focal length of an optical system determines the size at which a subject is reproduced on film. Wide angle lenses show objects very small in the viewfinder because of their short focal length. Conversely, telephoto lenses make them appear larger, when shooting from the same distance.

The reference point in 35mm photography is the 50mm lens, the so-called, "normal or standard" lens. (Its diagonal angle of

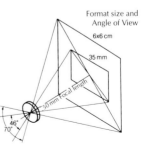

Format size and
Angle of View

6x6 cm

35 mm

50 mm focal length

46°
70°

Angle of view in photography is usually measured as the diagonal of the format size. This is the only way comparisons can be made with other shooting formats such as 6x6cm, also referred to as 2-1/4 square.

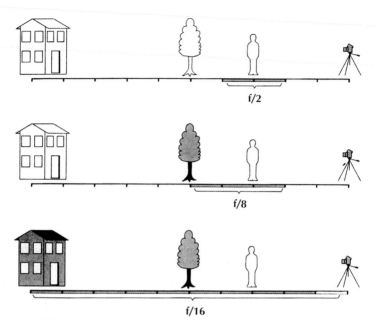

The smaller the aperture (opening), the greater the area which is reproduced in acceptably sharp focus - the so-called, depth of field.

view is approximately the same as that of the human eye, so it produces a "natural" perspective). Lenses of shorter focal length (like 28mm) are called wide angle and longer focal lengths (such as 300mm) are referred to as telephotos.

A short focal length offers a wide angle of view, denoted in degrees in specifications charts. Conversely, a long focal length records a narrow angle of view. And thus, the term "wide angle lens" can be readily appreciated. Their wider angle of view will include more of a scene in the frame than longer lenses from any given camera position.

AF Nikkor zoom lenses offer the greatest versatility, with some encompassing a broad range of focal lengths in a single barrel. A push or a turn of the zoom collar will noticeably change the magnification and include less (or more) in the frame.

Exploring Depth of Field

This is another term that routinely crops up in photography. It means the depth of the image that is captured in focus and it can vary greatly. We'll expand on this in a moment, but first let's review a bit of theory.

Any optical system can show only a single plane in sharp focus. Anything that is in front of that, or behind it, is considered to be out of focus. Therefore, only a single specific point is actually razor sharp in any photo.

Fortunately, our eyes adapt quickly; they view everything which appears *reasonably* sharp as being in focus. In some landscape pictures, for example, the brain perceives sharpness from foreground to infinity. This is an optical illusion, occurring because of an apparent sharpness throughout the image.

Shallow depth of field: The only plane in focus is in the background while the foreground is blurred because a wide aperture was used.

A small aperture (f/22) and suitable point of focus allowed for a sharp rendition of both the foreground and background subject.

Consequently, depth of field is best defined as the zone of *apparent* sharp focus. This can be extensive as in the example above, or very narrow, as in a sports photo with a blurred background and foreground. The ability to control depth of field will take the N50/F50 owner from snapshooting into the realm of creative photography.

Depth of Field Factors
Although it is a complex technical topic, the principles governing depth of field can be summarized in four points:

The wider the aperture, the shallower the depth of field: At a wide f/2.8, the zone of sharpness will be considerably less than at f/16, for example. Only the primary subject will be razor sharp, with its surroundings blurred to some extent. (A diagram in this chapter illustrates this point).

Longer focal lengths produce shallower depth of field: You may already have noticed that "selective focus" is more readily achieved with longer lenses. To confirm this point, shoot with a 300mm focal length first, and then with a 35mm lens from the same position. Set f/5.6, focusing on a person 10' away. With the longer lens, only the subject will be in precise focus in your picture. Unlike a the wide angle lens, the 300mm lens produces a narrower range of sharpness, blurring the background into a soft wash of color. This is a desirable effect when you want the viewer's attention riveted to the center of interest.

The closer the subject to the camera, the shallower the depth of field with any lens: Focus on a tree 16' away, and others in the frame will be acceptably sharp as well. Some of the trees closer to the camera, and others behind the point of focus, will fall within the depth of field. If you set focus for a tree only 5' away, little else will be rendered sharp in the picture. (In both cases, the actual range of acceptable sharpness varies based on the factors mentioned in the first two concepts, above).

Telephoto lenses, used at close range at wide aperture, produce extremely shallow depth of field. The background is pleasantly "soft" here because f/4 was consciously selected.

Depth of field generally extends one third in front of the point of focus, and two thirds behind: Consequently, focusing a third of the way into a vast scene will help to maximize depth of field at any given f/stop.

Varying Depth of Field

The effect of depth of field on any image is considerable. Imagine a portrait with a busy background - the trees, weeds, poles and cars all appear quite sharp. This effect was achieved in one of three ways: with a small aperture (like f/16), a wide angle lens or moving back from the subject. Prefer a cleaner look with soft blurring eliminating the obvious clutter? Then switch to a longer lens, move in closer and open the aperture to f/4, for instance.

Or consider a landscape, including foreground trees, an S-curve of a river in the mid-ground and peaks rising majestically to the sky in the distance. Apply the first three factors (mentioned in the previous section) and you will minimize depth of field. In the final picture, both the trees and distant mountain will be blurred. Only a section of water will appear to be in focus.

Not the intended effect? The solution is easy: switch to a wide angle lens (perhaps 28mm) and stop down to a smaller aperture (perhaps f/22). Set focus for the rocks a third of the way into the scene. Now the depth of field will be far more extensive, keeping the entire scene in acceptably sharp focus for a full appreciation of its beauty.

Controlling depth of field through a decisive selection of focal length and aperture is one of the most important photographic tools. This is one reason why a portrait photographer might use a 135mm lens at f/2. Both factors are a conscious decision, used to minimize depth of field to defocus the background. Now the subject is sharply etched against a soft blur, a pleasing effect.

In other situations he may want to maximize depth of field for sharpness throughout the frame, as for an environmental portrait. Here, both the carpenter and tools in his workshop should be reproduced in sharp focus. Hence the use of a 24mm lens at f/22. This will create an effect which could never be matched by a telephoto with its narrow angle of view and shallow depth of field.

Note: All this works fine in theory, but a small aperture will call for a long shutter speed. So, f/22 in the example above may

require a 1/15s exposure, with ISO 100 film. This mandates the use of a tripod, or an ISO 200 film for a 1/30s exposure. (Flash could also be used). This is another of the tradeoffs inherent in photography.

Assessing Depth of Field

Re-read the previous sections and you will note we often referred to the effect visible in the final picture. While the single lens reflex camera is highly versatile, it is not perfect. You always view the subject at the widest aperture, with the least depth of field. Consequently, you will notice no difference between f/5.6 and f/22 but the two pictures you take will look quite different.

The more expensive cameras such as the Nikon N90/F90 do incorporate "depth of field preview." As you stop down from f/5.6 to f/16, for example, you can press a button which will allow you to actually see the range of sharpness increasing. This is not included in the N50/F50 in order to keep price/complexity low.

More importantly, perhaps, depth of field preview causes a darkening of the viewing screen as you close down the aperture. By f/11 you can barely see the subject, except in bright light. Hence it is difficult to determine whether depth of field is just right.

Although you can get used to viewing a dark image, this is academic with the N50/F50 as with most cameras in this league. Because they do not include a preview function, you will need to estimate depth of field. Remember this fact: depth of field is shallow at f/1.4 to f/5.6, greater at f/8 to f/16 and increases noticeably by f/22 and f/32.

Hint: We strongly suggest that you add the above information to your diagram of the f/stop series. This is another of those critical photographic concepts which can be difficult to remember. Refer back to it when reading other chapters of this guide, and they will probably make a lot more sense.

Shutter Speed or f/stop?

As we have seen, the two exposure control mechanisms comple-. ment each other perfectly. Because they are both based on the same doubling principle, you can close down the aperture and

extend the shutter speed while maintaining accurate exposure. Or open up the aperture and set a higher shutter speed without affecting the overall brightness of the final image. Or close down the aperture and extend the shutter speed by an equal amount.

The exposure will be equivalent in all three cases except in extremely long exposures, usually over one second with most films. (The latter problem occurs as a result of film characteristics, and is not a flaw in the theory of equivalent exposure). Consequently, it does not matter which you adjust. Yet, the emotional

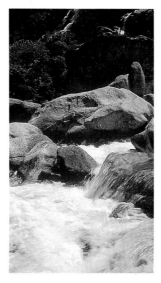

impact of each picture will differ. We have already explained this briefly and provided a few photos to illustrate the concept. But let's examine another example to make this all crystal clear.

Creative Control

Let's say you want to photograph a flowing stream clogged with a few chunks of ice with a short telephoto (135mm) lens on the N50/F50, mounted on a tripod. In "A" mode,

A long exposure produces an impression of flow or motion in a still photograph. Naturally, long shutter speeds call for a tripod or other firm support to prevent loss of sharpness from camera shake.

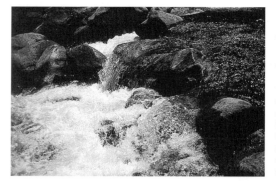

Water "freezes" into individual droplets when recorded with a fast shutter speed. This creates an image which is foreign to our experience as we never see it this way.

take a shot at f/22 and the N50/F50 will select a 1/15s shutter speed in this hypothetical situation. Then switch to f/2 for the second picture, and the camera will respond with a 1/2000s shutter speed. If you refer to your chart of f/stops and shutter speeds, you will note that both will produce an equivalent exposure.

This occurs because we opened the aperture as we shortened the exposure time *by exactly the same number of increments.* Doing so maintained the same exposure but varied two factors: the range of apparent sharpness and the depiction of motion.

The first picture will depict the rushing water as a swirling, unsharp white mass that gives the impression of actual movement with a very dynamic feel. The small aperture (f/22) renders the branches in the foreground, as well as the background chunks of ice, in acceptably sharp focus.

The second picture will offer a dramatically different impression: the previously romantic flow is now frozen (at 1/2000s) into a series of droplets, some in mid air. The branches are merely a distracting blur while the chunks of ice are shapeless blobs further downstream.

The very large aperture (f/2) has drastically reduced the depth of field. Secondary elements which were important to the composition can no longer be identified, eliminating the sense of place and time which were contained in the first picture (at f/22).

Equivalent Exposures
Of course, we have provided only the extremes in this example. In reality, there is a wide range of apertures/shutter speeds in between the two. These offer freedom of choice, in that all for the following combinations would lead to the equivalent (same) exposure, in the situation above.

1/15s	and	f/22
1/30s	and	f/16
1/60s	and	f/11
1/125s	and	f/8
1/250s	and	f/5.6
1/500s	and	f/4
1/1000s	and	f/2.8
1/2000s	and	f/2

Note: Actually, the N50/F50 allows you to select intermediate apertures and shutter speeds such as f/19 at 1/20s. Consequently, this list could be expanded substantially. Set your own camera to "A" mode and check all of the available combinations for yourself in the viewfinder data panel. This will vary depending on the lighting condition.

Film Selection Criteria

Most hobby photographers are, unfortunately, rather careless when it comes to film. They routinely pick one based on price or ready availability at the corner store. The manufacturer, type, speed, and the advantages of each are often overlooked.

This is really a shame since you are spending a great deal of energy to capture some decent images on that film. The diverse subjects we photograph will vary dramatically, so a film which is perfect for one may well be inappropriate for another.

So give your recording material some overdue attention. At the very least, decide whether you'd like slides, desirable for their brilliance and three dimensional look when projected. Or do you prefer color prints? Or would black and white film be preferable for that visit to a reconstructed 1860's village? And do you plan to use flash, or would an ISO 400 film allow you to shoot with available light?

Defining Film Speed
We have used the acronym "ISO" frequently; it merely designates "International Standards Organization", a group which sets film speed numbers for consistency. ISO and film speed refer to the light sensitivity of any recording material. Each type requires a specific amount of light to produce an accurately exposed image in its silver halide crystals.

A doubling of the ISO number corresponds to a doubling in sensitivity. The standard speed today is ISO 100, but the possibilities are wide: from a very "slow" ISO 25 to an incredibly "fast" ISO 3200.

The ISO 25-100 films boast finer grain and higher sharpness than the faster versions. Therefore, loading an ISO 1000 film would make little sense unless it were truly necessary. Besides,

A magnifier, such as the LGL Light Gathering Loupe from Saunders, can make it easier to examine and evaluate negatives, photographs, and contact sheets.

the N50/F50 would close the lens down in bright conditions, curtailing your photographic freedom. And don't forget the price difference: the higher the sensitivity, the higher the price.

We always carry a variety of films, from ISO 50 to 1600, in order to be prepared for any eventuality. We also carry both color slide and print films as well as b&w film. Depending on the subject, lighting condition, a need for prints, etc. we select the "right" film from the stock at hand.

Superior Film Technology

Photochemistry has come a long way in the last few years. Kodak, for example, succeeded in improving black & white film emulsions with T-grain crystals. (The "T" denotes "tabular".) Conventional silver-halide crystals - the light-sensitive building blocks in emulsions - are cubic and three-dimensional in form. T-grains,

This old west street scene was shot with Kodak T Max ISO 100 film. Its fine grain structure and wide tonal range resulted in this excellent quality black and white image. Photo: Peter K. Burian

on the other hand, are flatter and more consistent in size: roughly "tabular" like an aspirin tablet. Their light-capturing surface is significantly larger. Incredibly fine grain, greater definition of intricate detail and higher sharpness is the result.

Combined with other advances, T-grain produced a stunning improvement in the quality of other film types too. Kodak's Elite slide film, with its extraordinary sharpness and freedom from visible grain, produces excellent detail. Natural skin tones, rich color saturation and high color contrast complement these features.

Development in color negative films have been equally impressive. The first Kodak Gold films with T-grain technology offered substantial improvement a few years ago. The third generation (called Ultra Gold in some markets) went far beyond that again. The new films follow the trend of improved color reproduction, micro-fine grain and remarkable sharpness. They are also more tolerant of exposure errors, producing acceptable

An emulsion with T-grain crystals. The flat silver-saline crystals produce excellent sharpness; their even distribution in the emulsion leads to a micro-fine grain.

prints even if the camera's meter was led astray by unusual lighting conditions.

Note: Naturally, Fuji, Agfa, Konica, Ilford and other manufacturers have also made tremendous strides in emulsion technology. Consequently, an ISO 400 film today is often comparable to one of only ISO 100 from five years ago.

These days, one of the ISO 200 print films should be considered the "universal" film. That's because "slow" lenses, with small maximum apertures, are common. It is twice as sensitive as ISO 100, a full "stop" faster in the terminology discussed earlier. If you frequently use your N50/F50 with the AF 35-80mm f/4-5.6, or a zoom of similar maximum apertures, an ISO 200 film is a sensible choice. This more sensitive film offers a bonus of extending the effective range of flash.

Time exposures, like this Bath, England scene, are easy and rewarding. Using ISO 100 film and an aperture of f/8, the photographer tried exposure times of 8, 14, and 20 seconds. Photo: Paul Comon

Demanding photographers found the Kodak Ektar series to be a first-class negative film. The rather slow Ektar 25 was the sharpest color negative film, capable of producing a 16x20" enlargement of excellent quality. It is best suited for still subjects because ISO 25 requires long shutter speeds unless you have a lens of f/1.4 maximum aperture and want to shoot at wide aperture.

The Ektar films were further improved in 1994. In some markets the name was changed to Royal Gold. A new generation of T-grain crystals and associated improvements led to even less graininess, more saturated colors, and better tonal values. The ISO 100 is perfect as a standard film for those who demand

superb technical quality. Even the Ektar/Royal Gold 1000 pro-
duces prints up to 8x12" with a tight grain structure few will find
objectionable.

Use a Good Processing Lab

The improved versions of all brands promise beautiful images, of
course. But this assumes that prints are made to manufacturers'
specs, and that's a presumption one cannot always make.

If you have been shooting with the N50/F50, the odds are in
your favor. Focus and exposure should be accurate in most cases,
so excellent prints should be expected. When your own pictures
come back from the lab, are the colors "off"? Are they much too
bright overall, or murky instead? Is the primary subject slightly
"soft"? Or do you notice distracting white specks?

If so, ask for reprints to be made. If these are still unacceptable,
and the lab cannot provide a valid explanation, start shopping
around. Take a strip of negatives to several labs. Then begin to
patronize the one which produces results you consider most pleas-
ing, with consistency of quality control from one week to the next.

Advanced Mode Functions

In a previous chapter, we introduced the various functions available in **ADVANCED** mode. Assuming that you have now reached a high comfort level with **SIMPLE** mode after actual shooting, switch the N50/F50 to the **ADVANCED** mode. You'll note that the four basic programs are available here, too, but with more displayed information and greater user control.

Before moving on to specific features, let's consider the sophisticated electronic technology which makes it all work.

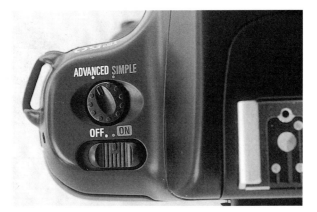

SIMPLE mode is fine for point and shoot photography, or when handing the camera to a spouse or child. Once you're ready for greater control, switch the N50/F50 to ADVANCED.

Automatic Focusing

Autofocus (AF) has become a standard in photography since the technology was refined several years ago. The N50/F50's AF system is based on the "Advanced AM200" module. This is the same module as is used in the "professional" F4, with two hundred CCD ("charge coupled device") elements. These are split into

If the AF sensor area (denoted by central brackets) covers an extremely reflective surface, the system will struggle to achieve focus. A plain, featureless surface such as a bald sky or blank wall also creates problems for this technology.

a pair inside the camera body. At the risk of oversimplifying a complex technology, we'll explain its operation in laymen's terms.

Like most SLR cameras, the N50/F50 uses a "passive" autofocus principle. In other words, it does not emit a beam (as with the "active" systems of compact 35mm cameras) to measure the distance to the subject. Instead, a technology called "phase detection" is employed. Each of the two CCDs views the subject, and the AF computer compares the images recorded by each to determine whether they are in phase: identical.

If so, the subject will be sharply rendered. If not, a microprocessor instructs a motor to move the lens elements to the correct position to focus on the subject within the AF brackets on the viewing screen. Just like your own eyes, the sensor requires contrast or texture, and a minimum brightness level, to focus. This explains why AF is not "foolproof" any more than our eyes are "perfect".

In action photography, the autofocus system is capable of tracking subjects moving at a constant speed toward or away from the camera. While the upscale N90/F90 is even more aggressive in tracking much faster motion, the N50/F50 should certainly meet the demands of the amateur photographer. A high school football game, cyclists tearing a round a park, and active teens should be child's play for this camera.

Single Shot Autofocus Mode

Under normal shooting, the N50/F50 operates in Single Shot autofocus, designated with an "S" on the pertinent screen of the LCD panel. So far, we have assumed that you are shooting in this AF mode.

Because focus can be locked, it is ideal in many respects. You need not frame the final picture with the primary subject dead center in the viewing screen. AF lock (gentle pressure on the trigger) allows you to recompose at your leisure.

Continuous Tracking Focus

But not every subject holds still as long as you want. Some run towards you, drive away or move around at will. When shooting such subjects, the N50/F50 can be set for Continuous autofocus, but only in **ADVANCED** mode. Now the system will track the subject, adjusting focus to keep it sharp.

To access Continuous AF, do the following: Press the menu button (open book symbol) once or twice until you see "AF" on the LCD panel. Press the button above it and the screen changes to read "AF S C" Press the button above the C and the camera is set for Continuous Focus Tracking.

Now the N50/F50 will follow-focus on a moving subject while you maintain light pressure on the trigger - as long as it remains within the AF brackets on the viewing screen! As soon as you point the lens at another target, focus is readjusted for the new distance.

⤺ **The focal length used here was 28mm, consciously selected to draw the viewer's eye into the image and produce a feeling of expanded depth.**

Continuous AF is ideal for action photography but sacrifices some creative freedom. At least a part of the subject (a horse, perhaps) must remain in the center of the image, limiting the compositional possibilities. Even so, the camera only fires after focus has been confirmed so you should return home with a high percentage of sharp pictures. (The most difficult technique is keeping a fast moving subject covered by the central AF brackets).

With the N50/F50's intelligent "predictive" autofocus, the odds of success are maximized. There is always a delay from pressing the trigger to the moment the shutter actually opens. Though measured in milliseconds, even a skier can travel quite some distance during this time. By anticipating the probable position of the subject at the instant of exposure and focusing on that spot, predictive AF is far more successful than early Continuous autofocus.

But there is a third option as well. If the N50/F50 is in the standard AF "S" autofocus mode, it will automatically respond when detecting motion. If the object within the central AF brackets begins to move, Continuous focus is activated. As long as the subject keeps moving at a constant speed, tracking focus is maintained. Subsequently, the system switches back to normal operation. Try this without film, with cars approaching along the street outside your home.

Note: Focus Tracking is automatically cancelled when the subject changes direction or begins moving erratically. The system then reverts to regular autofocus operation.

The Manual Focus Alternative

Because we found the AF system of the N50/F50 successful, we rarely needed to switch over to manual focus. Nonetheless, Nikon has retained the ability to focus manually for reasons discussed later. *Flip the lever on the front of the body from "AF" to "MF" and the camera is set for manual focusing.* This is possible in both **SIMPLE** and **ADVANCED** mode.

The lens' focusing ring is now released, responding to manual rotation. As you do so, you can see the point of sharpest focus changing on the viewing screen. The black dot in the viewfinder display panel appears, confirming focus on any given point. Nat-

urally, this approach is not as fast as autofocus, but some situations will call for hands-on control.

You will soon notice that focusing on the screen is easiest at longer focal lengths. The reason is simple: the depth of field is limited, so the subject pops into obviously sharp focus. This is particularly noticeable because you are viewing through a wide open aperture with any SLR camera.

Hint: When using a zoom lens, select the longest focal length to set focus on the subject. Then zoom back to the original focal length for the desired composition. This will assure the most precise focus possible in both manual and autofocus. However, when shooting quickly, this tactic is not essential. Conversely, focusing a wide angle lens can be difficult because everything appears sharp at first glance. Turn the ring back and forth. Watch the subtle change in the point of focus carefully; use the confirmation signal in the viewfinder for guidance.

When to Use Manual Focus
We have already mentioned some of the difficulties encountered by any autofocus SLR camera, but there are other reasons for switching to manual focus. If, for example, you are shooting through leaves or other nearby details, the AF system will cause frustration. It will focus on the foreground instead of your intended subject.

Manual focusing is also useful when you are shooting from a tripod. In such cases, you normally point the lens at the subject and lock the tripod head. You do not want to change this composition in order to set focus (on a rock to the side of the frame, for instance.) Hence, manual focus is less troublesome than autofocus in such situations.

When shooting extreme close-ups of nature subjects with high magnification (of an AF Micro Nikkor lens, for example) it's best to switch to manual focus. Let's say you want to record the pistil and stamen of a tulip. Start by setting rough focus only. Then move the camera in minute increments until exact focus is achieved. If it's mounted on a tripod, you'll need to move the entire assembly unless you buy a device such as a focusing rail. The latter allows for shifting the camera in millimetres, ideal for quickly reaching a position which offers sharp focus.

Advanced Matrix Metering

Multi-segment evaluative light metering is a Nikon specialty. They were the first manufacturer to introduce a camera with an early form of such metering. The Nikon FA of 1983 was a resounding success, encouraging camera manufacturers to refine the technology even further. The N50/F50 has benefitted substantially from this research and development.

The principle behind Matrix metering is intelligently conceived. The light metering sensor is subdivided into six zones in order to measure brightness in several segments of a scene. Unlike rudimentary center weighted meters which take an "average" of the light values, Nikon's Advanced Matrix meter is far more sophisticated.

Nikon's Matrix metering is used in all program and semi-automatic modes. In the N50/F50, it is composed of six individual segments which read light in various areas of the scene.

It analyzes the brightness range recorded by each segment, setting the "best" exposure given the relative contrast in a scene. It will ignore or limit the emphasis on extremely bright or dark peripheral areas.

Thanks to the vast strides in technology, Advanced Matrix Metering can recognize and cope with a great variety of lighting patterns. By comparing the situation at hand to those programmed into its memory, the N50/F50 automatically makes the corrections an experienced shooter might make after much consideration. The system also operates with flash, producing pleasing exposures both indoors and out with Matrix Balanced Fill Flash.

Limitations of Matrix Metering

The Advanced Matrix Metering system of the N50/F50 is highly successful in most lighting conditions, particularly with print films. This includes backlighting as well as scenes with extremely bright or dark areas in the image. The Advanced Matrix meter

The N50/F50's Advanced Matrix metering system mastered this backlit situation without the need for any exposure compensation. (Landscape Program).

can even handle sunsets automatically, producing beautiful results without severe underexposure.

Of course, terms such as "backlight" are relative. In extreme conditions, the contrast between the bright background and the actual subject can be well beyond the recording ability of the film. In such cases, flash is essential to obtain a pleasing image.

Then, too, when the subject occupies only a small part of the frame, and the bright surroundings overwhelm it, any system can be fooled. A distant skier on a snow covered hill or a conch fisherman against a whitewashed Caribbean building may be underexposed. With a dark scene, like a water buffalo against black rocks, some over-exposure will result.

A mediocre print with gray whites and great loss of shadow detail.

An excellent print made from the same well exposed negative.

This should create little concern if you're shooting negative films. The wide exposure latitude will often allow for good prints to be made. Switch to slide film however, and even a minor metering error will be noticeable. Thankfully, the Advanced Matrix meter of the N50/F50 produced a high percentage of nicely exposed slides in a broad variety of more common conditions.

Hint: With Advanced Matrix Metering it is rarely necessary to override the system when using negative films. (However, do use flash in extreme backlighting to keep the subject bright). With slide film, exposure accuracy is essential. The overall effect can be improved with moderate exposure compensation. In the ski hill example above, a +1 factor should be applied unless flash is used. In the Caribbean example, a +.5 factor would produce a cleaner look. With the dark scene, a -1 factor will produce blacks instead of dark gray. (This topic will be covered in more detail later).

Frankly, when taking your negatives to a lab with automated equipment, your prints may not come back perfectly exposed. While the film's latitude is great, the printing system can be fooled by bright or dark scenes or by a predominance of red, for example. In that case, the lab should apply the appropriate overrides when making reprints.

New D-type Nikkor Lenses

The N50/F50 is the second Nikon camera (after the N90/F90) which can benefit from the use of the new AF Nikkor series lenses. These are identified with a "D" which stands for "distance".

Mount a D-type lens and the N50/F50 provides 3D Advanced Matrix Metering with Distance Data Detection. An "encoder" in these AF Nikkor lenses detects and relays camera-to-subject distance information to a microcomputer. The Matrix system analyses this data and makes the calculations necessary for correct exposure even in extremely complex lighting conditions.

By evaluating distance in addition to contrast and brightness, the odds of exposure accuracy are increased. This improvement is not dramatic. With print films, it's unlikely that you will notice any difference. With slides, certain high contrast situations will be more accurately exposed (optimized for the subject in sharpest focus).

At press time, 18 AF Nikkors with the distance signal chip had been announced. This number will increase, ensuring access to a full system of optics which can take maximum advantage of the N50/F50's high tech metering system.

Note: The N50/F50 will produce fine results even with the standard AF Nikkor lenses, particularly with print film. While exposure analysis is more precise with D-type lenses, we were impressed with the results produced by the earlier AF Nikkor series in Advanced Matrix metering.

Fuzzy Logic Technology

While it may seem to be a contradiction in terms, "fuzzy logic" is a powerful form of artificial intelligence. Because the N50/F50's

Advanced Matrix Metering incorporates this technology, let's briefly examine its value in practical terms.

The primary advantage is the ability to make smooth transitions when effecting any changes which are required. As the brightness level changes ever so slightly or your subject moves into light shade, adjustments in exposure are made in minute increments. (This is possible with any AF Nikkor lens.)

Imagine a toddler roaming in a large area of dappled sunlight, created by overhead branches and leaves. The brightness level fluctuates imperceptibly as you track his progress. Your color slides should offer consistent exposure from frame to frame as fuzzy logic prevents abrupt (large) variations in exposure during continuous shooting. In a nutshell, this technology's methods of evaluation are more like the continuous human thought process.

Locking the Exposure

The N50/F50 locks and holds focus while gentle pressure is maintained on the trigger, except in Continuous AF mode. However, the exposure reading is _not_ locked! In **ADVANCED** mode, try panning the camera from side to side with light pressure on the trigger. You will notice that the exposure data at the bottom of the viewfinder are constantly changing. They are corresponding to the brightness level of the current image. And this is exactly as it should be in most cases. After all, you frequently want the exposure to match the ultimate composition, as in a landscape or travel scene.

In other cases, as with a deep sea fisherman, you may decide that the opposite would be more effective. Locking the exposure

reading on the subject and then recomposing to include the ultra bright ocean may well produce the preferred effect.

Maintain pressure on the AE-L button to lock and hold the exposure reading while you recompose.

To lock and hold the exposure reading taken from a certain subject or composition, do the following: Point the lens at the primary subject at the longest focal length if using a zoom lens. Press the AE-L button on the right rear corner of the N50/F50. Then recompose (or zoom back) with exposure locked, with light pressure on the AE-L button. Naturally, focus can be controlled independently with pressure on the trigger if you want to lock AF as well.

Center-Weighted Metering

The N50/F50 offers a second metering pattern, but only in Manual exposure mode. Select "M" and the camera automatically switches from Matrix to center-weighted metering.

Now the light meter accords special emphasis to the area in the middle of the viewfinder, denoted by an etched circle. This section is weighted at approximately 75%. This meter can be useful in situations where you want to base exposure on a specific area. The surrounding area is considered in the final assessment as well, at a ratio of 25%. This offers a backup in case the central subject is extremely bright or dark. Thus, the odds of an acceptable exposure are increased slightly.

Center-weighted metering allows a specific area of the subject to be carefully metered. (This may require moving closer, or zooming in, and then returning to the original composition with AE Lock.) Then, based on experience, any desired exposure correction can be used to achieve particular effects such as intentional over- or under-exposure. We'll discuss this topic in detail shortly.

Testing the Matrix System

Under most circumstances, you will allow the Advanced Matrix Metering system to set the exposure. We would suggest that you sacrifice two or three rolls of slide film to testing Advanced Matrix metering. (If you were to use a negative film, the end result would be overly dependent on the printing equipment instead of the camera.)

Go out and shoot extreme cases to test the N50/F50's performance in a broad variety of difficult conditions. Try shooting through foliage into an evening sun, a few rocks in a pond with extremely bright reflections, mirrored surfaces, and small subjects in front of bright (and dark) backgrounds. Now you will have valuable sample slides. You can now determine when you should trust the Matrix meter and when you should take control by overriding the camera selected exposure or using AE Lock (or flash) as explained earlier.

Exposure Overrides

Before moving on to personal control of exposure in Manual mode, let's consider exposure compensation in Program and the semi-automatic "A" and "S" modes.

In **ADVANCED** mode, the N50/F50 gives you plenty of latitude to change the exposure: 5 full "exposure values" up and down! (One "exposure value" corresponds to one full aperture or shutter speed increment.)

Access to this function is exactly as you'd guess: Press the menu button (open book symbol) once or twice until a [+/-] symbol appears in the LCD display panel. Press the button above it and you'll see a 0.0 plus an arrow pointing up and another down. For extra exposure (to brighten a scene), press the "up" button for "+" exposure compensation. For "-" compensation (to darken a scene) press the "down" button. The readouts will change in half step increments. Pressing the "+/-" button returns the screen to normal.

The N50/F50 automatically switches into center-weighted metering in Manual (M) mode. The area within the etched reference circle receives 75% of the metering emphasis. The surroundings are "weighted" at only 25% in the final exposure equation.

Note: The exposure compensation which has been set is now in effect for all future frames until reversed! A "+/-" symbol in the viewfinder and the LCD panel warns that a compensation factor is in effect. Remember to cancel this once it is no longer required! (To do so, repeat the above steps to return it to zero. Or press and hold the menu and self timer buttons simultaneously for three seconds to return the camera to its standard settings.)

Fully Programmed Operation

Now let's return to a detailed review of each of the Program modes, starting with the General Purpose program depicted by a camera symbol with the word "**AUTO**" in the external LCD panel. Its primary emphasis is on short, hand-holdable exposure times, whenever possible, depending on the lighting level and the focal length in use.

As the brightness level increases, the Program combines smaller apertures with faster shutter speeds (both are adjusted simultaneously). In low light, when the shutter speed cannot be maintained at hand holdable levels (e.g. 1/60s at 50mm focal length), a warning is provided. A camera symbol blinks rapidly in the LCD panel. You should look for a stable support or consider using flash. The blinking lightning bolt in the viewfinder means the same thing.

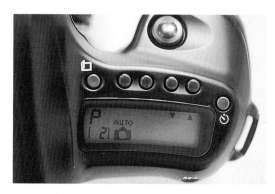

In ADVANCED mode, the settings made by the Flexible Multi Purpose Program can be "shifted" to longer exposures with smaller apertures or shorter exposures with wider apertures.

Flexible Program

In "**AUTO**" program, the camera adjusts both aperture and shutter speed to produce accurate exposure, adapting to any changes in lighting or the reflectivity of various subjects. While this is the same in **SIMPLE** mode, you now gain a significant advantage. "Multi Purpose Program" becomes "Flexible Program", allowing you to temporarily adjust the camera-selected shutter speed/aperture combination.

As discussed in the previous chapter, many combinations of these two factors provide equivalent exposure. But the depth of field and the depiction of motion will differ when the aperture size/exposure time combination is varied. The camera automatically maintains the same "flow of light" to the film, so the overall exposure remains constant. You can temporarily override the camera selected values (in half stop increments) in **ADVANCED** mode:

To use the flexible program: In AUTO/"Flexible Program", press one of the two far right keys for Program Shift. The one designated with an upward arrow shifts to smaller apertures with longer exposure times (for greater depth of field/fluid motion). The other shifts settings to wider apertures with shorter exposure times (for shallower depth of field/frozen motion).

Some 8 seconds after a function button was used, or your finger was removed from the trigger, the system reverts to its own preferred settings. The next time you touch the trigger, or after taking the picture, you'll need to shift again unless satisfied with the camera selected settings.

Note: Program Shift is indicated by a "P" in the LCD panel and two arrows pointing in opposite directions in the viewfinder. If the light level is excessive for the selected exposure time/aperture size combination, "HI" blinks in the viewfinder. "LO" blinks in the opposite scenario. In that case, shift again to another combination until the symbol disappears.

The Program Shift option is deactivated when the built-in flash head, or an accessory speedlight, is active. The N50/F50 will still produce pleasing pictures with flash, though without user control of aperture/shutter speed in program modes.

The fully programmed "AUTO" mode made this fast candid shot possible. The person completes the visual triangle that consists of the posts guiding the eye into the image, plus the window. This composition required instant response, without time for changing camera settings.

Subject Programs

Landscape Program

When designing the Landscape Program, Nikon appears to have made two logical (but not certain) assumptions. The first premise is this: there will be some sky in a landscape. Consequently, the metering system compensates to prevent underexposure of the foreground.

The second premise is,"*Whenever possible, everything should be sharply rendered, from the foreground to the background, in*

The Landscape Program is most useful where there is clear depth in a scene, including a nearby foreground. This program is designed to produce extensive depth of field, an effect best achieved with a wide angle lens.

landscape photography". For the majority of photographers using a Program mode, this is a valid assumption. In order to produce that effect, with extensive depth of field, the camera attempts to maintain an aperture no wider than f/8 as long as possible. It only starts to open up the aperture if the shutter speed is likely to fall below 1/60s. (Use an ISO 200 to 400 film to get smaller apertures in dim light).

Whenever you want the N50/F50 to select small apertures, Landscape Program is a suitable choice as long as there is adequate light. Hence, it's useful for other subject types such as outdoor group portraits, where depth of field should be adequate to keep everyone reasonably sharp.

Portrait Program

The experienced photographer will often select a focal length between 85mm and 135mm for portrait work, sometimes moving

The Portrait Program is most appropriate with longer focal length lenses. The system selects the widest aperture to minimize depth of field. If you also move in close, the subject can be sharply rendered against a soft, blurred background.

up to 200mm or 300mm to isolate the subject from the background. And the Portrait Program is built on this premise. Using it with shorter focal lengths would rarely make much sense as depth of field would be excessive.

This Program routinely opens the lens to the widest aperture possible. With the long lens, this results in shallow depth of field. Now, the subject is distinct from the background unless the latter is quite close; that is, within the zone of apparent sharpness. The exposure is controlled using the shutter speed alone. (As we'll see, the semi-automatic "A" mode can be used to achieve the same result. To do so, the owner needs to understand the concepts and cannot rely purely on symbols.)

Note: When flash is activated, the system is often unable to maintain a wide aperture except in low light. The shutter speed (often 1/125s) takes priority over the f/stop. This assures a nicely exposed picture, but with greater depth of field in bright, outdoor conditions.

Otherwise, Portrait Program is suitable for any situation when you want the widest possible aperture, regardless of subject type. Naturally, this will also produce high shutter speeds as required to maintain correct exposure.

Close Up Program
The N50/F50's standard lens, the AF 35-80mm f/4-5.6 D Nikkor, allows you to focus quite close even at 80mm. With this capability, you can move in and record a large blossom or a model airplane without additional accessories.

When shooting in this manner, we tend to use a tripod for two reasons: to allow the use of an intermediate apertures such as f/11 for adequate depth of field, and to assure ultimate image sharpness at long shutter speeds. In close-up work with a zoom lens, depth of field is usually adequate at f/11 to encompass the entire subject without including a distant background.

However, Nikon appears to have assumed that the vast majority of N50/F50 owners will shoot handheld. Consequently, its Close Up strategy calls for wider apertures to prevent camera shake from creating blur. The second assumption is that the world is filled with clutter and distracting elements. Consequently, the Program selects f/4 to f/5.6: often a more logical choice than f/11 to blur it away with shallow depth of field.

Unless the light is extremely bright, Close-Up Program will not select apertures smaller than f/5.6. Depth of field will be quite shallow at 80mm or longer. This is rarely a problem unless you use high magnification macro lenses (AF Micro Nikkor); in extreme close up work, depth of field is very limited.

Note: This Program works nicely with flash, filling in hard shadows. However, the shutter speed is given priority so the selection of aperture becomes secondary. Therefore, in bright light, the system may select f/11 at 1/125s, providing more depth of field than intended by the Program designer.

You'll find subjects which are suitable for Close-Up Program most anywhere. Only your imagination limits the number of available possibilities.

Sport Program

The N50/F50 includes a "Sport Program" but we prefer the term "Action Program" as that is less limiting in concept. Recommending the use of telephoto focal lengths of 80 to 300mm (especially of f/2.8 or wider aperture), Nikon has biased this Program toward high shutter speeds. This is maintained at 1/500s or faster as long as the light level allows.

These speeds freeze motion, useful in various applications. Children or pets tearing around, a soap box derby race, or any action situation will be sharply rendered as long as there is enough light. With a "slow" zoom lens (f/4 to f/5.6 maximum aperture), use an ISO 400 film on overcast days. This will help to assure hand-holdable shutter speeds.

The Sport Program freezes any kind of motion and is particularly useful with long focal length lenses.

Sport Program is most logically used with telephoto lenses as these are required to fill the frame in sports situations. The shallow depth of field is also useful to isolate the subject against a "soft" background so it will not compete for viewer attention.

Hint: Avoid using flash. Otherwise, the N50/F50 is forced to prioritize the shutter speed for an accurate flash exposure, often at 1/125s. Besides, your subject is likely to be beyond the range of all but the most powerful speedlight.

Silhouette Program
To the best of our knowledge, Nikon is the only manufacturer to offer this Program, probably because it is so specialized. It is also easily misunderstood. The Silhouette Program is only intended for situations including a dominant subject in front of a much

The Silhouette Program should only be used when the foreground is to be rendered as black, against a significantly brighter background.

brighter background. A lighthouse, standing on weather-worn rocks by the ocean at sunset, is but one suitable subject. The building will be intensionally underexposed: rendered as a silhouette, because exposure is automatically compensated.

We would not recommend this Program for standard sunsets as conventional Matrix metering produces superior results. It is really useful only when there is a darker subject - palm trees perhaps - against a much brighter background such as the sun and sea. Needless to say, Silhouette Program is definitely not suitable for use with flash since that would defeat the entire purpose.

Caution: Never look at the sun with your naked eye or through a camera. Damage to the retina may occur, causing permanent blindness.

Night Scene Program

Because Matrix Balanced Fill Flash is designed for average situations, Nikon offers Night Scene Program more suitable for pleasing twilight and night shots outdoors. Ambient light illuminates the background, while flash is used to brighten a nearby subject such as a friend sitting outdoors with a skyline in the background.

Typically, very long exposure times are selected, calling for a tripod or other firm support. This allows the darker background to register on film. The primary subject is illuminated by a brief burst from the pop-up flash head. Small apertures are selected, maximizing depth of field to include both the subject and a more distant background.

The long shutter speeds can improve your night or twilight shots considerably. The foreground will be nicely exposed by flash and the background will be quite bright instead of the typical black void common in such situations. The atmosphere of the image is increased significantly.

Motion Effect Program

We have previously discussed the use of long shutter speeds to create an illusion of movement in still photography. This Program promises to achieve such effects as the symbol, a runner with motion streaks, suggests.

Cyclists, athletes, a cascading waterfall, and other movement can produce pleasing motion blur at long exposures. Water droplets in a river or rain and snow take on their familiar forms instead of being frozen in mid air. Just as the eye perceives motion or flow, the effect can be simulated in a photograph.

In our view, Nikon has not gone far enough with Motion Effect Program. While shutter speeds are indeed longer than in the Multi Purpose Program, they are rarely long enough! In our experience, the system still attempts to prevent the effects of camera shake, selecting 1/60s far too often with ISO 100 film. This may be acceptable with ultra-high speed motion, but slower subjects are rendered quite sharply with little motion blur.

Consequently, we preferred to switch over to the semi automatic Shutter Priority ("S") mode. For small waterfalls, we selected a 1/4 sec. exposure; for motion blur with joggers, a 1/15s exposure, and so on.

These two pictures show the different effects of two subject Programs. The left one was taken with the Motion-Effect Program and the water is rendered as flowing. The camera selected 1/60s and hence small aperture that made the background, particularly the house, come into focus.

The second picture was taken with the Portrait Program which keeps the depth of field to a minimum. Although the water is not "flowing" as nicely as before, the background is blurred out of focus because a wide aperture was selected. The difference between these two pictures is not really that great because the lens was fairly "slow". With the AF Nikkor 35-80mm f/4-5.6 D, the camera could not select wide apertures (such as f/1.4) in the Portrait Program. Bear in mind that the water would become increasingly sharp and less flowing at wider apertures because the shutter speed would be even higher.

Hint: Keep an eye on the shutter speed in this Program. If it is not adequately long to create the desired effect, switch over to "S" and take over control. But remember: you will need to use a tripod unless "panning with the motion". That technique will be described later.

These two pictures demonstrate the value of shooting the same subject with user-controlled shutter speed and aperture. The left image was taken with the Multi Purpose Program. The exposure is perfect but the fast shutter speed renders the flow as "frozen": unnaturally so.

The other was taken in Aperture Priority mode at f/11, consciously selected. The corresponding shutter speed was 1/45s, a bit long for handholding the camera at an 80mm focal length. Note the increased depth of field as well as the depiction of flow in a more natural manner. (The same effect could have been achieved in FLEXIBLE Program by shifting the aperture/shutter speed combination). Photographers who have some experience, will switch to the semi-automatic "A" mode because the f/stop selected will remain constant from one frame to the next.

The Debate About Automation

Some "serious" photographers scorn even the most intelligent Program mode, deeming this to be abandoning control to a computer. They insist on remaining in Manual to control every variable: exposure, depth of field, the rendition of motion, and so on.

Others view the customized Program modes, combined with Advanced Matrix metering, as a valuable amenity for occasional use. They find it convenient for subject-oriented photography, when getting the picture is more important than the process. In complex lighting conditions or in fast breaking action situations, they'll switch to one of the appropriate Programs without embarrassment.

Even the authors of this guide have slightly differing viewpoints on this topic. But we do agree that Program modes are not exactly technology's gift to mankind, nor are they totally without merit. All involve compromises. Any of the effects possible in a fully automatic setting can be replicated and improved upon by a skilled photographer using other options available with the N50/F50. This is why Nikon offers such "extras" even in an entry-level SLR.

However, when you want to increase the odds of capturing the decisive moment, do not hesitate to switch over to a Program. Select "**AUTO**" in ADVANCED mode if you want to shift aperture and shutter speed for some pictures. By making the necessary calculations and settings, the N50/F50 will allow you to devote time to important considerations: dynamic composition, watching the play of light and shadow, or capturing a baby's smile at a moment which will not recur.

Evaluation of Program Modes

Program modes can certainly be useful, but fully automatic shooting is not always ideal. Every program is based on the trade-off between aperture and shutter speed. Most of the programs limit the selection of shutter speed to minimize the risk of image blur from camera shake. Naturally, this also limits the choice of apertures, curtailing the "creative freedom" of the system.

In our estimation, the program modes were logically designed to assure technically good pictures, though with the usual limitations. That's why Nikon literature encourages photographers to

exert more control, switching to the semi-automatic Aperture and Shutter Priority modes, where these restrictions do not exist.

Program Rules of Thumb

After shooting with the various Programs in a multitude of situations besides the obvious, we offer the following suggested applications for the most versatile.

For	*a wide range of sharpness*	use	*Landscape*
For	*shallow depth of field*	use	*Portrait*
For	*freezing motion*	use	*Sport*
For	*long exposures with flash*	use	*Night Scene*
For	*group shots*	use	*Landscape*
For	*occasionally overriding*	use	*General Purpose aperture/shutter speed*

Advanced Metering Modes

Semi Automatic "A" Mode

When you switch into "A" mode, the N50/F50 allows you to freely select the aperture (by pressing the up and down buttons). The camera responds with a suitable shutter speed to maintain equivalent exposure. Its selections are "stepless." It is not limited by the standard set of shutter speeds but can select 1/419s or

You select the desired f/stop by pressing one of two buttons in Aperture Priority mode. The corresponding shutter speed is also displayed in the viewfinder.

on a sturdy tripod. Now, switch to manual exposure control (M) and hold the up button until TIME appears in the LCD panel (right after the 30s display). Two lines replace the shutter speed numbers in the viewfinder as a reminder that you alone control the length of the exposure.

Press the trigger and the shutter opens after a 1/2s delay. This permits vibration to dissipate to ensure a sharp picture. The shutter now remains open until you press the trigger again.

There is no need to cover the eyepiece in long timed exposures as the metering system is inactive. Exposure can be determined with an accessory handheld meter or set relying on your judgement. Photo magazines occasionally run articles with hints on long timed exposures, and these can be helpful for the inexperienced. While experimenting, shoot several frames, varying the time of the exposure. One should be quite satisfactory.

Set a wide aperture (such as f/2 or f/4) to avoid lengthening the exposure time unnecessarily. This is usually possible in night shots, as you normally focus at infinity. In that case, depth of field is quite adequate at any aperture so you rarely need to stop down to f/16 or f/22.

Shooting Fireworks
Another suitable subject for the TIME setting is fireworks. These shots are much easier than you might expect but a tripod is a prerequisite.

Set up the camera with the lens pointing at a section of black sky or a distant building which is lit. The latter can add some interest to your pictures as a secondary element. If the display takes place over water, try including the surface (for some frames) in order to get some reflections. Use a short focal length (such as 28mm or 35mm) and aim it at a likely spot; this will help to ensure that you'll capture at least some bursts on film.

There is absolutely no value in using a fast film for fireworks photography as the bursts are usually very bright. With an ISO 100 film, set an aperture of about f/8; with ISO 200, we find f/11 works nicely. If you must use ISO 400, set f/16 in order to prevent over-exposure.

Switch autofocus off and set focus manually, usually for infinity. With the N50/F50 set for "TIME", hold a black piece of cardboard in front of the lens and trigger the camera. When you see a

burst in a suitable area, remove the cardboard in order to expose the film. Then, put it back into place, awaiting the next burst with the shutter still open.

We find that recording three or four on one frame produces a pleasing effect. However, if you are including a lit building, use f/16 at ISO 100, recording no more than two bursts. This will prevent over-exposure of the background. Press the trigger to close the shutter when desired.

Take as many shots as possible as insurance since this is a trial and error technique. Vary the focal length if using a zoom. In some cases, the exposure will not be pleasing. In others, you will have recorded only a small section of the display or the composition may not be acceptable. It's impossible to pre-determine how the individual effects will look on film. After all, you have no control over the situation, unless staging your own fireworks display. Nonetheless, you'll come home with some stunning photos which will be well worth the effort.

Flash Photography with the N50/F50

When combined with a flash unit - particularly one of the sophisticated speedlights - the N50/F50 becomes a more versatile camera. In this chapter we'll review the various features and provide some hints on getting better pictures with a burst of artificial illumination.

The N50/F50 automatically provides proper exposure for subjects depending on the range of the flash unit which is used. This is possible because the camera contains a separate flash metering cell which reads light reflected off the film when the shutter opens. As soon as sufficient exposure has been received, the system turns off the flash output. This through-the-lens (TTL) reading is quite accurate, whether the pop up head or an accessory speedlight is used.

Even when a filter (such as a polarizer) is used on the lens, a TTL reading remains accurate. Because the light actually striking the film is measured, the camera compensates for any loss of light. In typical conditions, you can select whatever aperture or shutter speed is desired, or delegate this task to a program mode.

We said "in typical conditions" because in extremely low light, selecting f/16, for example can result in underexposure of a distant subject (due to inadequate light output). Several factors determine the maximum flash range: distance to the subject, the aperture size, brightness level and film sensitivity.

Flash with Nikon Speedlights

Although the N50/F50 incorporates a pop-up flash head (reviewed later), some owners will invest in an accessory flash unit. This purchase will be motivated primarily by a need for greater versatility and extended "reach" for distant subjects. The built-in flash is deactivated when a speedlight is mounted, reducing drain on the camera's lithium battery.

Note: Most of Nikon's Speedlights are fully "compatible", but not all features of each will operate with the N50/F50. That's because

some of the flash functions are actually controlled by electronics within the camera. As an affordable "entry level" model, the N50/F50 is not packed with all the computerized systems - in comparison to the higher priced N90/F90, for example.

Consequently, some advanced functions touted in the Nikon Flash System brochures cannot be accessed: High Speed Synch, repeating (strobe-effect) flash, rear curtain sync, red-eye reduction, etc. with the SB-25, for instance. In our estimation, this is not a major drawback. Owners of the N50/F50 are less likely to experiment with these more esoteric features.

As we'll see however, all of the basic flash functions operate with the N50/F50. These are used in 90% of flash photography even by advanced amateurs, so your scope will be restricted only 10% of the time. Besides, the SB-25 (Nikon's most sophisticated speedlight) costs about the same as the N50/F50. Hence it is a more suitable companion to the upscale N90/F90 in any event.

Guide Numbers

The measure of a flash unit's power is the so-called guide number. For consistency, every guide number is quoted in feet (or meters) in reference to ISO 100 film and a 50mm focal length. The guide number is useful when manually calculating the aperture required, but this technique is beyond the scope of a guide to an entry-level camera.

The actual range of any flash unit will not equal the guide number in conditions encountered in actual photography. No flash unit in the world provides a range equalling its guide number. Perhaps in a hypothetical "ideal" situation this would be the case, but in real world photography much light is lost. Consequently, we will quote guide numbers only as a means to comparing one flash unit to another.

Note: The higher the number, the greater the distance the flash can illuminate. In comparing flash units, remember this. Doubling the guide number actually results in a quadrupling of power. Hence, the SB-25 will have a "reach" far greater than that of the SB-23, for example.

Matrix Balanced Fill Flash

With either the built-in TTL flash or a Nikon Speedlight set at "TTL" the N50/F50 provides an advanced technique called Matrix Balanced Fill Flash. This fully automatic system balances the exposure for the background (ambient light) with the flash exposure for the foreground. The result is a pleasing, natural effect without the black background common with less sophisticated flash metering technology.

Matrix Balanced Fill Flash works not only in bright situations but also in dim light within a limited aperture/shutter speed range. For specifics, skip to the sections covering flash use in the various modes of the N50/F50.

Hint: For most normal photography, the results will be very pleasing. When the subject - or background - is extremely bright or dark, the exposure may not be fully accurate. Since negative films are quite "forgiving", your lab will be able to make a fine print most every time. With slide film, the results are likely to be superior in such difficult conditions when a D-type AF Nikkor lens is used, as explained in a subsequent section.

Matrix Technology

With conventional TTL (through-the-lens) control, as found in less sophisticated cameras, the flash fires when the shutter opens. Light is then reflected back from objects in the scene, bounced off the film and diverted to a metering sensor. This sends a reading of overall brightness to a microcomputer, which makes the necessary calculations. A signal is sent to stop the flash when its output is deemed to have been appropriate.

This works quite effectively in many circumstances, but not always. For example, consider a scenario where the subject is relatively small, and the background is far behind it: a wide angle environmental portrait perhaps. Most of the flash illumination passes by the subject and is never reflected back. Thus, the center of interest is likely to be overexposed as the system has been "fooled" by the unusual conditions.

With the N50/F50 the 6 segment Advanced Matrix meter first evaluates ambient light and the "contrast": the variation in reflectance between the subject and the background. Then, its micro-

computer makes an analysis of the situation. Flash output is compensated and balanced with ambient light through a fuzzy logic computation. The final exposure is generally optimal for the overall scene.

Flash Metering with D-Type Lenses

The above process is automatic with any AF Nikkor lens. Switch to a D-type with Distance Signal chip, and the Matrix computer can also consider camera-to-subject distance. Now it more readily recognizes that you're shooting a small subject against a distant background. So when the flash fires, the computer ignores readings from the irrelevant areas, more effectively optimizing exposure for the subject.

This "3D" flash metering (denoting **D**istance **D**ata **D**etection) is particularly useful when dealing with a small subject, as accurate determination of its location within the frame is essential. In a photo of an off-center model against a white backdrop, for example, 3D Matrix Balanced Fill-Flash is more likely to produce accurate results. It will prevent underexposure of the area in sharpest focus.

Note: In truth, even with standard AF Nikkor lenses the intelligent Advanced Matrix computer provides accurate exposures in most situations. In extreme contrast (difference in brightness between two areas) its success ratio increases when D-type lenses are used. If the subject is particularly dark - or bright - the system can better recognize the potential problem, and compensate accordingly.

TTL Flash in Manual Mode

Switching the N50/F50 to Manual mode activates center-weighted TTL flash metering. Now the camera's strategy is less sophisticated, since the Matrix computer is no longer involved. Frankly, we do not recommend a manual approach unless you are an experienced photographer intent on controlling all of the variables.

Only those with substantial experience with flash are likely to achieve the desired effect. Because the N50/F50 is essentially an entry-level Nikon, we chose not to provide a lengthy treatise on the subject of manual flash exposure control.

TTL Flash in Program Modes

For the simplest means of achieving pleasing flash photos, set the N50/F50 to one of the Program modes. With certain Speedlights this also requires you to set "TTL" on the flash unit.

Now the Advanced Matrix system sets a flash sync speed and an aperture which is appropriate for the ambient light. Its selection depends on subject distance, film speed, the ambient light level and other such factors. When the shutter opens, a final adjustment occurs, as the metering operation continues while the exposure is being made.

As mentioned in a previous chapter, TTL flash can be used to provide "slow sync" flash in Night Scene Program, with shutter speeds as long as 1s. (Long shutter speeds are also possible in Semi-Automatic and Manual mode, of course).

Programmed flash operation is ideal for quick shooting but you lose creative control over depth of field and the depiction of motion. Hence, for more serious pursuits switch to "A" or "S" mode. Experiment with a roll of slide film to gain a high comfort level with this less automated approach.

TTL Flash in Semi-Automatic Modes

The N50/F50 can be used for flash photography (with the Matrix system) in both Shutter-Priority (S) and Aperture Priority (A) modes. The primary advantage is that you are not restricted to the specific f/stop and sync speed selected by the computer. Hence, depth of field control becomes possible in "A" mode, and motion-blur effects in "S" mode at exposure times as long as 30s.

At shutter seeds longer than 1/60s (in any mode) the risk of blurring increases: due to camera or subject movement. This effect can be striking, if intentionally used for creative purposes.

After you set the f/stop or shutter speed, the camera automatically selects the second variable (depending on the mode in use). Matrix Balanced Fill-Flash provides the best possible exposure as long as the subject is within range of the flash at the selected aperture.

Limitations of Flash Automation

No matter how foolproof a system, certain principles of light apply. Keep the following in mind whenever shooting with flash.

With a speedlight of high guide number (especially when using ISO 400 film) a nearby subject may be over exposed. When shooting extreme closeups - less than 4' from the lens - switch to an ISO 100 film. In Aperture Priority mode, select a small aperture such as f/16. Or, cover the flash head with several layers of facial tissue to reduce its output.

With distant subjects, underexposure is possible if flash output is inadequate. This is a more likely problem, since most N50/F50 owners use the pop-up head or a speedlight of low guide number. Move closer, switch to an ISO 400 film, or open up to the widest aperture (such as f/4) in "A" mode. If your flash pictures are frequently underexposed (murky and grainy), you are definitely a candidate for one of the Nikon Speedlights with a guide number of at least 100 in feet (30 in meters).

Note: In Program modes, the N50/F50 will select the optimum f/stop automatically. However, if the subject is outside the range of flash (too close or too distant) you will need to use one of the other precautions mentioned above. (Check the distance charts in the Instruction Manual for the N50/F50 or the Speedlight). With negative films, your photofinisher may be able to compensate, and make an acceptable print, unless substantial under- or over-exposure has occurred.

A lead-in line is a useful compositional element. The viewer's eye ⇨ follows the railing into the picture, adding the illusion of depth.

⌂

Backlighting casts shadows towards the camera with the overall effect changing every few minutes as a result of the sun's movement. Wait and observe the lighting as it changes, shooting several frames over a period of time for the most interesting results. Use Matrix metering or try the Silhouette program.

◁ A carefully positioned foreground which frames the scene can add a sense of depth to a photograph.

111

⌂

Diagonal compositions are generally more dynamic than than a straight-on view. Move in close to fill the frame and crop out unimportant, distracting elements in the scene. A polarizing filter maximizes color saturation.

When photographing tall vertical subjects, there are two approaches ⇨ one can take. To minimize distortion, move back and hold the camera parallel to the subject. Include extraneous foreground elements. To accentuate the subject's height, tilt the camera upward so the subject is isolated and appears to tower over the viewer.

The Nikon N50/F50 is the perfect camera for travel photography because it is lightweight and compact.

The picture below is a typical tourist shot of Munich's Frauenkirche taken from Old Peter's Tower. It documents the structure and makes a beautiful, although unimaginative, snapshot.

The photograph on the right took some time and creativity to set-up, but it portrays the church as it is seldom seen. The silhoutte of the iron fence frames the towers and shows some of the beauty that is all around the city.

Manual focus allowed the photographer to set the precise point of focus that kept both the foreground and background reasonably sharp. Aperture priority mode was selected and f/16 chosen for adequate depth of field and a shutter speed fast enough to handhold. Matrix metering handled the exposure without requiring compensation to be set.

Synchronization Speed

The N50/F50 will synchronize with electronic flash at shutter speeds as fast as 1/125s - higher than the 1/60s which was standard with most cameras at one time. Faster shutter speeds cannot be set. This is a safety measure to ensure that the entire film frame is evenly exposed. If you were able to set a 1/250s exposure time with flash, only a portion of the image would be illuminated.

With the N50/F50 in Manual "M", "A" and "S" modes, the full range of 30s to 1/125s is available. The TIME setting for long exposures can also be used with flash in "M" or "S" mode. In this case, flash is triggered at the end of the exposure before the shutter closes. In Program modes, the system generally favors 1/125s except in dim light when 1/60s (or longer) is selected. In Night Scene Program however, long exposure times (down to 1s) are used, to allow the darker background adequate time to register on film.

Note: The flash illumination is very brief in all cases, measured in thousandths of a second. However, at 1/125s and longer exposures, the entire frame is evenly illuminated.

The Pop Up Flash Head

The built-in flash head can be raised and lowered when desired. In normal shooting, it is unobtrusive, but will pop up at a touch of the button. Focal lengths of 35mm and wider are covered, with uniform lighting assured.

With a guide number of 43 (in feet and 13 in meters) it's power is adequate for many typical applications, especially with nearby subjects. With ISO 400 film, the built-in head is really quite suitable for most picture-taking conditions. Although this built in

The N50/F50's technology eliminates guesswork and calculations to obtaining pleasing exposures, even in difficult situations like this display window.

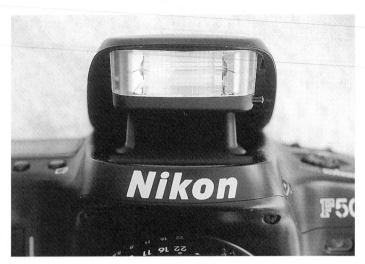

The built-in flash is both convenient and practical. It is never in the way, but is always ready when needed.

flash unit was not intended to replace the accessory speedlights, it is ideal for adding fill light outdoors. It can also be used to illuminate a subject indoors in typical interiors found in a home but not in an expansive area such as a sports arena.

Pop up the head and it is ready to fire as soon as the symbol stops blinking (in 2s or less). Until flash is recycled ("charged" for the next shot) the trigger is locked to prevent your taking a picture by accident. After the exposure has been made, the symbol should reappear within a few seconds unless the battery is weak and requires replacement.

Pop Up Flash Range

To maximize the range of the pop-up flash head, we recommend the use of an ISO 200 or 400 film with "slow" zoom lenses. Because the sensitivity of such film to light is higher, the effective range of flash increases. The Instruction Manual of your N50/F50 includes a distance chart in the SIMPLE section.

The built-in flash is very useful with close subjects even with slow (100 ISO) film. It provided the pleasing lighting for this portrait. The distance between the subject and background kept the background from being illuminated by the flash. ⇨

118

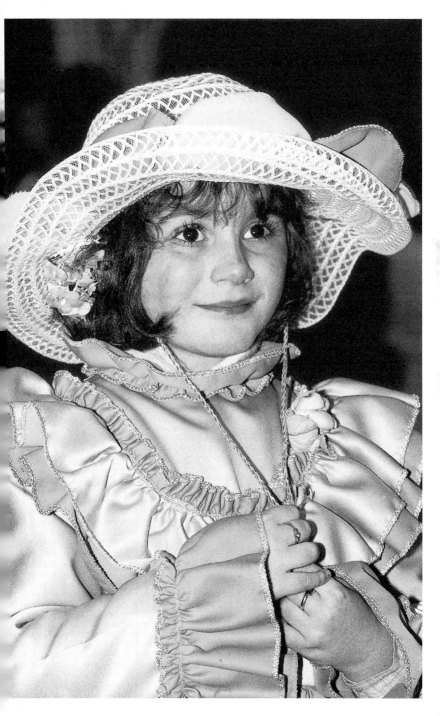

Note: With any flash unit, a blinking symbol (after the exposure) warns that the subject may have been beyond its range. Reshoot the image from a closer vantage point to be assured of a satisfactory result. As an alternative, switch to a "faster" film or a "fast" lens (such as f/1.8 or 2.8), select a wider aperture (in A mode), or use direct (instead of bounce) flash.

Flash Obstruction Concerns
Because it is built into the camera body, any pop-up flash head is extremely close to the axis of the lens. Consequently, lenses of wide diameter - or with wide hoods - can obstruct some of the light. This is particularly noticeable in close-ups, and less so with distant subjects. "Vignetting" (darkening of a part of the frame) can be expected with certain lenses and hoods.

Although we have strongly recommended the use of lens hoods to prevent flare in bright light, they can create serious problems when the pop-up flash head is used. Accordingly, it's best to remove the hood, and shade the lens from the side with a hat in extreme sidelighting. Or, use one of the accessory speedlights instead, as these sit much higher above the lens axis.

Although you can use lenses of 85mm and longer, do not use a focal length shorter than 35mm as the pop-up head cannot illuminate a wider angle of view. This should be kept in mind particularly with zoom lenses that incorporate a 28mm or shorter focal length. When using a zoom lens with a "macro" setting for extreme close-ups, the built-in head will not correctly illuminate the subject - lighting an area behind it instead.

Note: As outlined in the instruction manual, some AF Nikkor lenses should not be used with the pop-up head - at least at certain zoom settings. Because some of the light will be blocked (especially at distances less than 15') heed this precaution.

Current Nikon Speedlights

All of the functions described so far are available with either the pop-up flash head or one of the accessory speedlights which mount in the "hot shoe" of the N50/F50. We recommend an external flash unit because of its extra power and "autofocus

This cross-section shows the path taken by light entering the lens. Some is diverted to the metering sensor, while the rest travels upward to the viewing screen. This diagram shows an N90/F90, but the configuration is the same for the N50/F50.

assist illuminator" (discussed later). The following is a brief description of each current model; at least one is sure to have the power you need at a price within your budget.

SB-16B Speedlight

This is a "basic" unit with calculator dial, likely to be considered somewhat confusing by most N50/F50 owners. In our view, this model requires more effort than is appropriate for this camera. And it lacks an AF-assist illuminator, making low light focusing less reliable.

Its guide number is a respectable 105' (32m) with the zoom head set for 35mm. The SB-16B includes a manually selectable zoom head for flash coverage angle from 28mm to 85mm and longer. A wide flash adaptor is included for use with lenses down to 24mm. More importantly, the head will both tilt and rotate - allowing flash to be bounced from a wall or ceiling. Recycling times range up to 11 sec. and you can expect 100 flashes per set of AA batteries.

Note: As with any flash unit, recycle times and number of shots per set of batteries will vary. The estimates provided are based on use in full manual output! They improve in TTL mode, especially with subjects which are relatively close - except in extremely dark conditions.

SB-20 Speedlight

This is a particularly compact multi-function unit with 28-85mm zoom head (user-selected), tilting head for bounce flash from a ceiling, and a Guide Number of 100' (30m). Recycling time is only 6 sec. and you'll get at least 160 flashes with a set of alka-line AA batteries.

Note: All Speedlights with a "tilting" flash head will also tip downward, by 7 degrees. This precaution is essential for subjects less than 6' from the camera to ensure that the correct area is illu-minated.

SB-22 Speedlight

This is a more economical alternative, with fixed head for a flash coverage angle of a 35mm or longer lens. However the head can

bc tilted for bouncing flash from a ceiling. This can produce more pleasing illumination than direct flash which can seem quite flat.

Hint: For reasons which remain a mystery, we often see photographers shooting with the head tilted partly upward. Unless intentionally bouncing light from a ceiling (with the head set at the correct angle) do not tilt the flash head, unless you want uneven subject illumination.

With the wide flash adaptor the angle of coverage can be expanded for use with 28mm lenses. With a Guide Number of 83' (25m), the SB-22 is still quite adequate for most flash work in a large rooms in a home or apartment. Recycle times run up to 4 sec. and a set of batteries will power 200 bursts.

This is the unit we would recommend for most owners of the N50/F50, as it has substantially more power than the built-in head, and is still compact and affordable.

SB-23 Speedlight
This is the smallest and least expensive option, with a fixed head (with coverage for lenses of 35mm and longer) and an aperture/distance chart for easy reference. Recycle times are extremely brief (2 sec.) and four alkaline AA's will offer some 400 bursts.

On the down side, the guide number is only 66' (20m) - not much higher than that of the pop up head. Even though this unit is very compact and convenient, we would recommend a more powerful model, unless you plan to use a speedlight primarily to reduce drain on the camera's (expensive) 2CR5 lithium cell.

SB-25 Speedlight
This is the top of the line speedlight with a guide number of 118 in feet (32 in meters) at the 35mm zoom setting. This increases to 138' (42m) by the 50mm setting of its zoom head and to a remarkable 164' at the 85mm setting. Recycle times vary between 7 and 30 sec. with alkaline AA's. Fresh batteries will last for about 100 full-power flashes.

Its zoom head can be adjusted for use with lenses from 24mm to 85mm (and longer), and down to 20mm when the built-in diffuser panel is used. The flash head will both tilt and rotate, although the distance scale on its LCD panel will disappear when

The SB-25 electronic flash unit has a multi-position head which is especially useful to bounce light off a nearby surface.

The large LCD panel on the back of the SB-25 provides detailed information about all important functions.

doing so. However, the exposure will be accurate as long as the distance to the subject is not beyond the range of illumination. (If the flash symbol blinks in the viewfinder after the picture has been taken, move closer or bounce the light from a less distant surface).

Although this is the "Cadillac" of speedlights (in terms of the multitude of features), only a limited number of its functions will

124

operate with the N50/F50. That's because this (affordable) camera does not contain all of the computerized systems necessary to access all of the advantages of the SB-25. This is understandable, as the SB-25 is a professional Nikon Speedlight which is far more likely to be used with the upscale bodies such as the N90/F90.

The SB-25 will work in the TTL mode but the other advanced functions are not available except for user-control in Aperture Priority, Shutter Priority and Manual modes of the camera. A very large (and illuminated) LCD panel displays the important information for ease of use. Set the N50/F50 to "M" mode, and you can reduce the flash output: in 18 steps from 1/1 to 1/64. But it takes a lot of expertise to produce the intended results, so we recommend this only for those willing to experiment.

Note: When used with the N50/F50, film speed, working aperture and zoom head positions must be user-selected with the appropriate buttons on the SB-25. Read the f/stop from the camera's display panel, and set the same number on the SB-25. A variable bar graph then shows the correct flash range with the current settings, as a useful indicator.

In the right situation, fill flash can really make the photograph, but it is not always the best solution. The picture at the left was taken using only ambient light. Separation between the boy and his surroundings is maintained because of the subtle shadows. The picture on the right uses fill flash. It seems flat by comparison because the flash eliminated the soft shadows which added depth.

Should you forget to set the film speed and correct aperture on the SB-25, exposure will still be accurate. Because flash metering is TTL (through-the-lens) gross errors will not occur. However, the distance scale will be incorrect, so it's worth pressing a few buttons.

Autofocus Assist

With the exception of the SB-16B, all of the Nikon Speedlights have an autofocus-assist illuminator. This will project a red (near infrared) pattern on the subject as a target for the AF sensor. Because of this amenity, you can take sharp pictures, even in total darkness.

The illuminator is also useful in moderately bright conditions, for focusing on a subject with little contrast of its own. However, once the light level increases beyond a certain point, it overwhelms the red pattern which is no longer of any value. If the AF system then struggles to find focus, try some of the techniques provided in an earlier chapter.

Better Flash Photography

Some photographers will use flash only as a last resort, preferring the more "natural" look possible with ambient light. And yet, flash can be highly useful, producing pictures most viewers will prefer in low light, in bright light or to even out extreme contrast in situations such as back lighting. Even in front lighting, Matrix Balanced Fill Flash automatically softens shadows and produces more detail in both light and dark areas.

We strongly recommend that you try flash on sunny days for more even foreground illumination, more saturated colors, and sharper detail. If you have yet to use fill to enhance outdoor pictures, try it with a broad variety of subjects from people to still lifes.

In some situations, ambient light alone may be more aesthetically pleasing, more effectively capturing the "atmosphere" or the play of light and shadow. Consequently, you may wish to shoot two frames in conditions where flash is not obviously required, one with and one without. Make comparisons after the pictures are developed to establish your own preferences.

Note: The above refers to daylight conditions. In low light, (without flash) you may need to use a tripod to prevent camera shake. And if the subject is moving, some blur will occur; this may or may not be the effect you intended.

Red-Eye Control
Whenever a flash unit is close to the lens axis (as in on-camera flash) "red-eye" is likely. This occurs especially in low light, because the pupil is wide open exposing the full surface of the retina. The light reflects off the blood vessels and the effect will be highly visible in the final picture. Several tactics can be used to reduce this undesirable syndrome:

• Brighten the room as much as possible, so the pupils will contract.
• Ask your subject not to look into the camera.
• Use a speedlight instead of the pop-up head as it sits higher above the lens axis
• Bounce flash from the ceiling
• Use a wide angle lens (such as 35mm) instead of a telephoto (such as 80mm) if appropriate.
• Move the flash head at least 1' away from the lens axis. This is the most successful strategy for preventing red-eye.

Note: Off-camera flash can be achieved with any speedlight - with the accessory SC-17 TTL Remote Cord. One end plugs into the hot shoe of the N50/F50 and the other accepts the flash unit. All functions continue to operate as if the speedlight were attached directly to the camera's hot shoe. For the most pleasing illumination, hold the speedlight at arms length above the camera and off to the side, with the head pointing directly toward the subject.

While red-eye cannot be totally prevented in dark conditions, these hints will help to reduce the effect so it is less noticeable in a 4x6 print. With off-camera flash, this syndrome can be almost eliminated, except in extreme darkness where it may be noticeable in larger prints.

Aperture Control

When shooting with flash in Program mode (especially outdoors), the working aperture is often rather small, so depth of field will be extensive. Any clutter, poles and other distractions will be highly visible in the final picture, even though they are not obvious when viewing on the screen.

Remember, you are viewing at wide aperture (shallow depth of field) while the taking aperture may be small (producing extensive depth of field). Take extra time to carefully scrutinize the viewfinder image. Change your shooting position slightly or zoom in tighter to eliminate distracting elements. In "A" mode, select wider apertures (such as f/4 instead of f/11) to moderate depth of field.

Note: Even with Matrix Balanced Fill Flash, the use of small apertures (such as f/16) may produce an unduly dark background. This is because of light intensity "fall off" (the light does not reach a distant background), most prevalent with low-power flash units. In some conditions, the darkness can actually mask clutter - as in nature close-up photography, for example. However, this effect is not "natural" so a wider aperture (for shallow depth of field) may be a preferable alternative with a distant background.

Eliminating Shadows

Noticeable shadows on backgrounds are unavoidable when you are using direct frontal flash for subjects close to a wall, for example. There are three solutions. Ask your subject to move further from the wall so his shadow will not fall on the backdrop. As an alternative, use the SC-17 cable for off camera flash; hold it high so shadows fall down behind the subject. Or bounce flash from the ceiling if your speedlight has a tilt head ability. In that case you may need to use an ISO 400 film due to light loss. The distance from the speedlight to the ceiling, and then to the subject, may be too great at ISO 100 in dark conditions.

Hint: Bouncing flash from a ceiling also provides softer, more evenly-distributed illumination. Look for a pure white surface to use for bounce flash. Otherwise, an unpleasant color cast can be expected. With negative film, the lab may be able to correct this, given adequate time and skill.

128

Reflectors and diffusers, like the Lumiquest Promax 80-20 shown here, are excellent for photographing people. They soften the light from the flash to reduce harsh shadows and create lighting that looks more natural.

The only drawback to the bounce technique is that people are sometimes rendered with dark eye sockets, as the light is coming from above. In our experience, a "light modifying" accessory is actually more effective for people pictures: with on-camera or remote flash. These mount on the speedlight, adding a bounce surface or diffusing the light, depending on the type of device employed. LumiQuest is but one manufacturer which offers a variety of accessories useful for flash photography.

The N50/F50 with Data Back

In some markets, the camera is available as the N50D or F50D as well, denoting a standard data back. If yours is not suitably equipped, the back can be ordered as an accessory later.

The data back allows you to record the date on the slide or negative, if and when desired. That information can make sorting your shots at a later date much easier. This is ideal for a family album, some vacation pics and documentary photography.

When shooting an entire series on a trip to France, or during a birthday party, for example, you may not want the date on every picture. In that case, set it to print for only the first frame on each roll.

The data back increases the camera's functionality. A built-in quartz clock automatically keeps track of long and short months as well as leap years. It can be programmed for various styles such as "day/month/year" etc. The data back uses a 3V lithium cell, type CR2025. Changing the battery is a very simple operation.

Along with the date, the day and time can be added to the frame. This feature will be rarely used except in unusual cases such as an eclipse of the moon or certain business applications. The LCD panel on the camera back confirms the data which will be imprinted on the frame.

The date is placed in the lower right corner of the frame - in horizontal format, that is! When you turn the camera for a vertical shot, it moves to the upper right corner if you rotate the camera as Nikon expects.

Place the camera in the palm of your right hand so that your right thumb operates the trigger. This grip doesn't take too much getting used to but is rather easy to forget when you only rarely add the date to your frame.

The area where the date will appear should be as dark as possible and by no means red: otherwise, the numbers would almost certainly disappear. On occasion, an ultra bright background will also obliterate the data but it should be visible in most of your pictures.

Setting the data back to "print" adds the date to the corner of the picture. A dark background is recommended for the imprint to be visible.

Whether a data back is an essential accessory or a simply fun novelty is up to each owner to decide. For serious photography, you'll rarely want to record the date or time on the pictures. But for family and travel snaps this information can be greatly appreciated.

Nikkor Lenses

Nikon has established a solid reputation among professional photographers which is due in part to the excellence of Nikkor lenses. To achieve this goal, Nikon offers both exceptional optical quality and a comprehensive selection. Amateurs benefit on both counts as the lens that earns the pro his fee can also be used by the photo enthusiast for pictures of superior technical quality.

Lens Compatibility

The N50/F50 was designed to be used with AF Nikkor (autofocus) lenses. More notable is the fact that it can access the advantages offered by the D-type AF Nikkor's which transmit information about subject distance to the matrix metering system.

We do not recommend the use of manual focus Nikkor lenses except in a pinch. Although they are "compatible" with the N50/F50 in theory, they do not allow for the use of most essential functions. Neither autofocus, the metering system, nor the various exposure modes will operate. The only option is manual mode (M) where only the shutter speed is displayed in the LCD panel. The f/stop is selected by turning the lens' aperture ring (unlike use with AF Nikkor lenses). Because no metering support is available, you'll need to use a handheld device or the hints packed with film. You can focus manually with assist provided by the confirmation signal which (surprisingly) remains active.

Although this will produce acceptable pictures, the loss of just about every other amenity makes conventional Nikkor lenses impractical for regular use with the N50/F50. (The two AI-P series manual focus telephotos do maintain greater compatibility but these professional instruments are probably too expensive for N50/F50 owners).

Nikon has always prided itself on maintaining some compatibility among its products, even as new generations of cameras and lenses replace the old. Most of their other autofocus bodies do retain grater compatibility with earlier AI-S and AI lenses, but

compromises were made when designing the N50/F50. The purpose was to keep the price affordable, a logical decision in our estimation for an entry-level SLR.

Lens Compatibility Specifics
Despite the above, there are a few lenses which must not be used with the N50/F50. While you may be able to mount these, some damage will occur. **Check the instruction manual for specifics.**

However, the following series of Nikkor lenses remain "compatible" to a varying extent with the N50/F50:
1. Nikon Series E lenses.
2. All non-extreme AI-Nikkors (AI-S, AI and lenses converted to AI) and the two AI-P telephotos.
3. Nikkor 500mm f/8 mirror lenses, serial number 143001 and higher.
4. Teleconverters except TC-16 and TC-16A.
5. All AF Nikkor lenses are fully compatible.

This list excludes lenses such as the manual focus super-fish-eyes and super-zooms (180-600mm) etc. but these are of little interest to the enthusiast. For the rest of this chapter, we will survey only the AF Nikkor lenses, as these are the most commopnly used with the N50/F50. Due to space constraints, specialized items such as PC Nikkors, Reflex lenses and teleconverters will not be discussed.

AF Nikkor Lenses

At last count, the number of AF lenses had grown to 30, and 14 of these were of the D-type series with the Distance data chip. We are excluding the new AF-I series of telephotos with built-in focus motors because they will not autofocus with the N50/F50 (but are otherwise fully compatible). Such a wide range of high quality lenses gives you an enormous creative scope: from fish-eye lenses which encompass a 180 degree view, to various macro lenses for extreme close-up work and on to the 300mm telephoto lenses for sports and wildlife in controlled conditions. And, best of all, there's a full assortment of zoom lenses with maximum versatility packed into a single barrel.

Zoom lenses were once scorned because early models pro-
duced mediocre image quality at best. But the current generation
has been improved dramatically, to the point that most profes-
sionals include at least one in their arsenal. Outselling single
focal length lenses by eight to one, this type has become the stan-
dard for most photo enthusiasts, and rightly so.

Today, optical quality is high, with every AF Nikkor zoom
capable of producing exceptional prints to at least 8x12". Some
go well beyond that, matching the optical potential of some sin-
gle focal length (or "prime") lenses. Naturally, their ease of use
and practical advantages make zooms a best seller. When shoot-
ing from a fixed position, you need not change lenses; a push or
a turn of the ring suffices to change the composition.

A zoom lens does not restrict you to the specific focal lengths
of other lenses, but allows for continuous adjustment for precise
framing - at 39mm, 46mm, 77mm and so on. More importantly, a
single zoom like the AF Nikkor 75-300 f/4.5-5.6 takes up much
less room in a camera bag than the three or four others it
replaces. And while AF Nikkor zooms are not cheap, you can
acquire one for a fraction of the cost of several "prime" lenses.

The Zoom Lens Debate

In spite of all the accolades, we'll admit that zoom lenses are not
exactly ideal in every respect. There are definitely some tradeoffs
in return for the convenience, but these are not as great as some
would have you believe. Let's consider the drawbacks you'll hear
mentioned and explain how each can be overcome for excellent
results.

First, maximum apertures are relatively small in comparison to
the "prime" lenses of single focal length. Particularly when a
zoom is made as compact as possible, while encompassing a
broad range of focal lengths, it is unlikely to be "fast". When sin-
gle lens reflex cameras were sold with a 50mm "normal" lens,
anything slower than f/1.8 was considered unacceptable. With

**Unless you are particularly wealthy, it is unlikely you'll ever acquire all ⇨
the lenses of your dreams. Fortunately, a zoom lens can take the place of
several fixed focal length lenses at a fraction of the price.**

today's zoom lenses, a maximum aperture around f/4 is highly respectable. Typically, this f/4 diminishes to f/5.6 at longer focal lengths.

Frankly, this is irrelevant for most amateur photography. An ISO 400 film puts you back on equal footing with the 50mm f/1.8 lens. And the sophisticated TTL flash metering systems of the F50/N50 produces beautiful results, reducing the need to shoot with available light. Because today's films are infinitely better than those made 10 years ago (when f/1.8 lenses were common) we see much less need for "fast" lenses.

By changing your vantage point and lens focal length, you can take an infinite number of interesting shots at a single location.

Granted, Nikon could design and build a 70-210mm zoom with constant f/2 aperture. But the price, size and weight would make it prohibitive and no one would buy it. Even the AF Nikkor Zoom 80-200 f/2.8D is considered too large/expensive by most photo enthusiasts. And this is by no means a "fast" lens in comparison to those of f/1.4 or f/2 which were once common.

Variable Aperture Concerns

The "variable aperture" technology as found in the AF 70-210 f/4.5-5.6D offers several benefits. Although the maximum aperture reduces as you zoom toward 210mm, its weight drops by half in comparison to the AF 80-200 f/2.8D. Image quality is highly respectable, although the "fast" lens boasts superior optics due to the special glass that is included in the optical formula of that expensive zoom.

136

The AF 75-300 f/4.5-5.6 (and several others mentioned later) proves that zoom lenses need not give up anything in terms of image quality. In order to compete in the market, Nikon, too, offers some affordable zooms. These may not match the stellar results possible with a "prime" lens, but will satisfy the vast majority of photo enthusiasts. Some of these "amateur" AF Nikkor zooms (like the AF 75-300 f/4.5-5.6) are also used by professional photographers because of their light weight and optical potential.

Because of its through-the-lens metering system, the N50/F50 compensates for the variable aperture. Although light transmission is reduced as you shift to longer focal lengths, exposures remain accurate with or without flash. Because the system measures the light that actually reaches the film, no matter what the actual f/stop, there is no need to compensate for the reducing aperture size. And with the N50/F50, only the largest aperture varies as you shift focal length. Set f/8 in "A" mode and it remains f/8 at any point within the zoom range.

It's tempting to dismiss zoom lenses because of the "disadvantages". And yet, in spite of the complaints we still hear, both of the authors of this guide use such lenses frequently. Some of our

most successful pictures were made with a Nikkor zoom. While we own "prime" lenses, too, for specific purposes, neither of us would be willing to give up our zoom lenses.

Shooting with Zoom Lenses

You'll notice we used the term "optical potential". This refers to the fact that even the best lens will produce unsharp pictures unless a few precautions are taken. We have already discussed the need for proper holding techniques and the value of a tripod (or other firm support) in producing sharp pictures. The use of flash is also helpful, but some zooms will block the burst of light from the pop-up head as mentioned in the previous chapter. And remember that any lens produces the highest resolution at the mid range of apertures, usually from f/8 to f/11.

Unless there is an overriding need to shoot at wide or small apertures for depth of field or shutter speed control, try shooting around f/11 for the sharpest possible results with any zoom lens. Avoid shooting directly into the sun or other strong light sources. Use a lens hood (or "shade"), an accessory available for every AF Nikkor zoom. This will help to reduce flare which is stray light striking the front element that can degrade overall sharpness and contrast.

When first using zoom lenses, it's tempting to take several pictures of every scene. You may find yourself standing at the roadside, shooting at 70mm, 125mm, 175mm and 210mm without varying the composition. You'll come home with four pictures, each including slightly less in the frame than the last. But unless the situation was particularly spectacular, three of these will probably have little impact. Select the most effective focal length for any scene, checking the various possibilities as you zoom, before taking the picture.

Varying Perspective With Zooms

It's a known fact that varying focal length can change apparent perspective. A 20mm lens shows the Grand Canyon in a completely different manner than a 200mm lens from the same shooting position. On the other hand, there is rarely much value in shooting the scene at a half dozen different focal lengths from 35mm to 80mm, for example.

Decide which will most effectively give you the result you desire. Try viewing the scene from several positions: higher,

lower, to the left, to the right, and so on. Check the effect produced by several focal lengths, and take the picture when the situation looks "best". Varying focal length is an essential element of photographic expression but should be used intentionally, not merely to prove the versatility of a zoom lens.

A 300mm focal length, for instance, does more than just "bring distant objects closer." It manipulates distance, and compresses perspective, stacking near and distant hills closer to one plane. Exactly the opposite occurs with short focal lengths. They expand perspective, pushing objects further back than your own eyes perceive.

An extensive discussion of these factors is beyond the scope of this guide. However, as you progress in your photography, you'll want to own at least two zoom lenses: perhaps an AF 24-50mm f/3.3-4.5 and an AF 75-300mm f/4.5-5.6. With these, you can cover 90% of the focal lengths used by the majority of advanced amateurs and create dramatic images matching those published in the finest magazines.

AF Nikkors Zooms

AF Nikkor 28-85mm f/3.5-4.5N Zoom

After this overview, let's move on to survey some specific Nikkor models. The first was particularly successful until the advent of the 35-80mm f/4-5.6D (standard lens for the N50/F50) and the AF 28-70mm f/3.5-4.5D. Both are smaller/lighter and include the Distance Signal Chip useful in Advanced Matrix Metering.

Nonetheless, the AF 28-85mm f/3.5-4.5N is a versatile zoom lens, worth considering if you do not already own one of the other two. In addition to the extra weight, its only real disadvantage is the use of a full 15 optical elements as opposed to only six and eight (respectively). Used to assure fine optical performance, the high number of elements does increase the propensity for flare.

This is a problem with any zoom lens containing many air-to-glass surfaces. And yet, even the renowned AF 80-200 f/2.8D (a favorite of many professionals) includes 16 elements, so this factor alone should not disqualify any lens from consideration.

AF Nikkor 35-70mm f/2.8 D

This is a very fast zoom alternative in and around the "normal"

The AF Nikkor 35-70mm f/2.8 D zoom lens offers a wide maximum aperture and excellent sharpness at any aperture.

focal length. It's fast, expensive, relatively large/heavy and a superb performer. Although not as versatile as some of the others, it is capable of producing images of professional caliber. Sharpness and contrast are first class at any focal length and particularly impressive from f/4 to f/11.

The front element of this push/pull zoom rotates while focusing. This can make the use of polarizers frustrating. But this is common with many zooms. (We'll mention only those which do not rotate). Learn to set focus first and then turn the filter ring to achieve the desired effect (darkening a pale blue sky, for example).

The "macro" setting, which is only available at the shortest focal length, allows for close focusing on a nearby subject less than 12" away. Because of the 15 elements which were required, this zoom is sensitive to stray light. Use the lens hood, your hand or a hat to shade the front element in extreme sidelighting.

AF Nikkor 35-70mm f/3.3-4.5

When compared to its "big brother" this more modest zoom exhibits marked differences: simpler optical formula, lower weight and size, and smaller/variable aperture. It is also more affordable, which is an important consideration.

With only 8 elements, flare is less of a problem. On the other hand, overall image quality is lower with this mid-priced zoom,

In the top picture, flare creates a bright "veil" of light over the image which reduces contrast and sharpness. Using a lens hood can make a dramatic improvement (bottom photo) if the flare is caused by side-lighting. Shooting directly into a bright light source can make flare unavoidable. You may need to change your shooting position.

as it is not as well corrected for optical flaws. Still, it will satisfy most photo enthusiasts.

The focal length range of 35-70mm is really a minimum for today's "normal" zooms. But these offer more scope than the 50mm fixed focal length lens. Shift from the shortest to the longest focal length, and the difference in perspective is noticeable. The difference between a 62° and a 34° angle of view is large enough to allow room for fine-tuning a composition.

AF Nikkor 35-80mm f/4-5.6D

This zoom is Nikon's "standard" lens for the N50/F50, and it's high on the price/value scale in terms of optical potential for the price. It is also compact so it will not block any light from the pop-up flash.

The focal length range from modest wide angle to short telephoto is adequately versatile for much photography. At 35mm the 62 degree angle of view is much wider than that of a 50mm lens, but is still easy to use, without the "exaggerated perspective" of

shorter focal lengths. At 80mm, it is adequate for a head and shoulders portrait of an adult.

The lens's fine optical performance is due in part to the use of an "aspheric" element. The downside is a relatively small f/4-5.6 maximum aperture, the price paid for compact size. Caution is advised in backlit situations to avoid the image degrading effects of flare. Order the lens hood (HN-2) and shade the front element in extreme side lighting. Check the viewing screen carefully, however, to ensure that your hand (or hat) does not intrude into the frame.

Holding the N50/F50 in this manner violates the rule regarding camera stability, but high shutter speeds in bright light should counter the effects of camera shake.

AF Nikkor 20-35mm f/2.8 D Zoom

This is the shortest focal length zoom available for the N50/F50. In a zoom range of only 15mm, it encompasses most of the ultra wide to moderate wide angle range. Expressed in terms of diagonal angles of view, the difference is far more impressive: from a full 92° to 62°. And a constant f/2.8 aperture makes it ideal for viewing and shooting in low light.

An aspherical element counteracts optical abberation for high sharpness from edge to edge of the frame. Use the lens hood to prevent flare accentuated by the 14 elements. This professional

lens is by no means a featherweight, and it costs roughly three times as much as your N50/F50 body! Unless you're wealthy (or a photo journalist), add it to your wish list in case a friend wins a lottery.

The AF Nikkor 20-35mm f/2.8 D is a preferred zoom lens of photojournalists due to its wide maximum aperture and superb optics.

AF Nikkor 24-50mm f/3.3-4.5 Zoom
Those who prefer wide angle to normal zooms will want this one as a frequent companion. It encompasses the range of very wide angle to the normal focal length in a relatively light weight package. Its close-focusing ability (.5m/1.6') is available throughout the range, a useful feature especially in wide angle work. Optical potential is very high, particularly from f/5.6 to f/8.

AF Nikkor 28-70mm f/3.5-4.5 D
This zoom lens is also a suitable alternative to the "normal" lens for the N50/F50 thanks to its small size and fine performance. At 28mm, it has a noticeable wide angle effect without the "exaggerated perspective" noticeable at 24mm. At 70mm it may be a bit short as a portrait lens, so you'll want a longer zoom as well. This one will probably become a best seller for Nikon, because it does not block light from the pop up flash of the N50/F50.

The AF Nikkor 28-70mm f/3.5-4.5 D zoom lens is ideal for use with the N50/F50 as it will not block light from the pop-up flash.

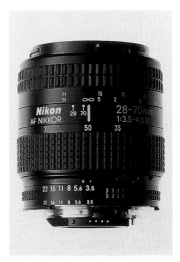

AF Nikkor 35-105mm f/3.5-4.5
Because the 105mm is preferable to even 85mm for portraits, this model extends beyond the previous zooms surveyed, including many useful focal lengths. It actually overlaps with those in a 70-210mm, so you might want to own both.

AF Nikkor 35-105mm f/3.5-4.5 zoom lens

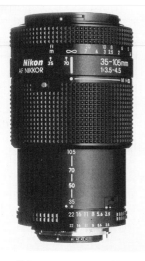

Optical quality was improved during the transition to AF mount, but a full 16 elements shows its complexity. This is evident in its weight, which is not really a problem but must be considered when hiking or walking great distances.

AF Nikkor 35-135mm f/3.5-4.5

Even more versatile, and including all the typical portrait focal lengths, this one deserves its popularity. At one time, 135mm was the norm for telephoto as it was the longest possible with the first small format camera, the Leica rangefinder. And it has an advantage: extremely pleasing perspective in close-ups of people without crowding the subject. This is the minimum focal light required to begin blurring away distracting backgrounds, although at f/4.5 this model is less than ideal in that respect.

A complex optical system is used with 15 elements, increasing the weight. In fact, this zoom is heavier than the N50/F50 body. But if you enjoy shooting portraits, this model will serve you well.

AF Nikkor 70-210mm f/4-5.6 D

This is the D-version of the original AF zoom, containing the Distance Signal Chip for 3D Advanced Matrix metering. This focal length range remains a best seller, and understandably so.

It's extremely versatile, particularly for candids: you can shoot from across the room, tripping the shutter at just the right instant. If you have been working with a short telephoto, the 210mm focal length will seem impressive. Contrary to popular opinion, it's excellent for landscapes (to isolate the most appealing components of a vast scene, instead of recording competing elements all in a single frame).

144

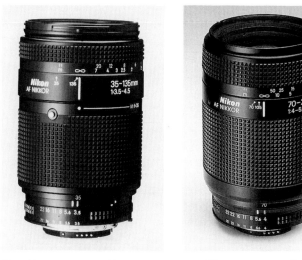

**AF Nikkor 35-135mm f/3.5-4.5
zoom lens**

**AF Nikkor 70-210mm f/4-5.6 D
zoom lens**

This lens is not particularly light but you won't leave it on the camera all the time. We consider it a complement to a second, shorter zoom, which extends to 70mm or 80mm only. The use of faster film (ISO 200 or 400) is recommended as the maximum aperture at 210mm is only f/5.6. For handheld work, you'll want a 1/250s shutter speed, rarely available except in bright light at ISO 100.

AF Nikkor 75-300mm f/4.5-5.6

This zoom incorporates several telephoto focal lengths, and has become a favorite of even some professional photographers. Photo enthusiasts will like it especially for amateur sports or animals in controlled conditions. A rotating tripod collar confirms what you would expect: at 300mm, a firm support is often essential unless shooting with an ISO 400 film.

300mm is the shortest focal length referred to as a super telephoto. The compression of perspective is very noticeable at this point, with cars, poles and pedestrians appearing closer together than the eye perceives. In close-focusing, depth of field is quite shallow, increasing the ability to emphasize the subject instead of its surroundings.

The extra weight can be an advantage in hand-held work, helping to stabilize the equipment; this reduces the risk of camera shake slightly. But shoot at 1/500s for maximum sharpness at 300mm. You may get by at 1/125s if you can brace your elbows (or the camera) on something rigid, but this will not guarantee the sharpest results.

AF Nikkor 80-200mm f/2.8 D ED
This is a personal favorite in the AF Nikkor Zoom line, a lens capable of pro caliber sharpness at any f/stop. Though expensive, it is not entirely out of reach. In fact, many advanced amateurs own (or are saving for) this heavyweight fast zoom.

The use of ED (extra low dispersion) glass assures high sharpness, color fidelity, and freedom from optical aberration. This precaution is most important with focal lengths longer than 135mm, particularly those with maximum apertures of f/2.8 or wider. Of course, the fast f/2.8 aperture is highly appealing, particularly since it remains constant throughout the range of focal lengths.

The combination of optical excellence and f/2.8 make this lens a real dream. Depth of field at the longest focal length is so narrow that important details can be isolated completely through the use of "selective focus". The background becomes a soft blur, particularly in the close-up range.

All this was achieved with technical complexity. This means 16 elements, great weight (43oz) and a large diameter - the filter size is 77mm, the largest of any current AF Nikkor zoom. (With

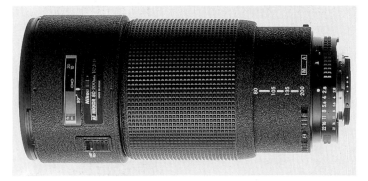

AF Nikkor 80-200mm f/2.8 D IF-ED

146

the D-type model, the filter mount does not rotate during focusing). Frankly, some find its weight excessive, particularly when carrying it any distance.

And the AF 80-200 f/2.8D ED lacks a tripod mounting collar, so you may need to buy an accessory. Check the photo magazines for ads for such a product since Nikon does not offer one. Nonetheless, this is one zoom worth saving for, as it will bridge the gap between professional and amateur, at least in terms of technical quality.

AF Nikkor Wide Angle Lenses

Modern zoom lenses have forced single focal length (prime) lenses further and further into the role of the specialist, often with wide maximum apertures.

A highly specialized unit can be found right at the bottom of the focal length scale, in the AF Nikkor 16mm f/2.8 D fisheye. With a coverage of a full 180° you'll need to use care not to include your feet in the picture. This is a true fisheye with the characteristic curving of lines, except those which run through the center of the image. Finding suitable subjects for a 16mm lens is difficult, try shooting upwards among a huddle of football players or some flowers or use it to record cramped interiors as spacious.

AF Nikkor 16mm f/2.8 D is a full-frame fisheye lens.

147

The fact that the foreground adds a sense of depth to any image is particularly true with a 16mm lens. But it must be extremely close because of a tendency to push everything back optically. Depth of field is incredibly vast even at wide apertures. This makes setting accurate focus a challenge, making autofocus useful. Frankly, few amateur photographers can justify the price of this fish eye, and fewer still can exploit its unique perspective.

Ultra Wides

The ultra-wide angle range starts with the AF Nikkor 18mm f/2.8D which has an undistorted diagonal angle of view of 100 deg. This term should not be confused with "perspective distortion" that naturally appears in the corners of the image and makes round objects appear spherical. This is simply a result of the extreme angle of view and is not due to poor optics.

AF Nikkor 20mm f/2.8 D

The photo enthusiast will prefer the AF 20mm f/2.8 because it is less expensive than the AF 16mm and 18mm lenses. It still offers an ultra-wide view (at 94deg.) with "expanded spatial perspective". Nearby subjects loom in the viewfinder, while those further back seem to recede dramatically. This tendency calls for some expertise to produce pleasing pictures. Look for a dominant foreground nearby, as distant subjects become mere specks in the frame. Fortunately, optical performance is excellent because of Nikon's strategies which correct for aberration in close focus work.

◁ **The characteristics of a telephoto lens are obvious in this photograph: shallow depth of field and compressed perspective.**

With any ultra wide focal length, keep the camera level to minimize "linear distortion" (explained in a moment). Unless aiming for an impressionistic result, the latter is essential and is best achieved on a tripod with an accessory bubble level. Shooting from a low vantage point will help to produce the most pleasing pictures with an ultra-wide angle lens like the AF 20mm f/2.8. Practice, experiment and shoot various types of subject matter until you master the wide angle perspective.

Standard Wide Angle Lenses
The wide angle range starts with the AF Nikkor 24mm f/2.8 with its 84° angle of view still produce marked "converging" perspective. If you tilt the camera upward, for example, vertical lines converge, while buildings seem to lean backwards.

This "linear distortion" is most noticeable with a wide angle lens. With some skill, you can minimize the effect or exaggerate it intentionally when shooting upward in a stand of trees or of skyscrapers in the city. Sharpness from edge to edge will be excellent even in close focusing work.

A 24mm lens can be used more often than a 20mm, because the apparent perspective distortion is not as noticeable. We consider this lens (or a zoom which includes 24mm) a fine starting point for extreme wide angle effects. After mastering a 28mm focal length, try a 24mm lens if you appreciate the creative potential.

Nikon offers three options in the modest wide angle range: the AF 35mm f/2, the AF 28mm f/2.8, and the AF 28mm f/1.4D. The latter is intended for pros, who can make use of its f/1.4 aperture, and can justify paying the high price. While all three of these lenses are stellar performers, most enthusiasts are best served by an AF Nikkor zoom which includes a 28mm and 35mm option.

"Normal" Lenses

The 50mm is the "normal" focal length for 35mm format photography. Cameras were fitted with this lens before the zoom revolution, and it is still useful when a wide aperture is required. The AF 50mm f/1.8 is quite inexpensive because the optical corrections required are minimal. Such a lens can save the day in low light

conditions or indoors when flash is not appropriate or is not allowed.

Unlike longer and shorter focal lengths, the 50mm produces a "natural" perspective. The pictures look very much like we saw the scene with our own eyes. There's no optical trickery here. On the other hand, a 50mm lens tends to produce "average" pictures in most hands. Used as a tool by a creative photographer, it can produce impressive results in spite of its fixed focal length.

Nikon offers a choice of two: the AF Nikkor 50mm f/1.4 and the AF Nikkor f/1.8. The difference is really not very great, f/1.4 is only half a stop faster than f/1.8. But the price is about three times higher because of the optical complexity. Think twice before spending the extra money. A 50mm f/1.8 is the fastest lens most of us will ever need, and this AF Nikkor is light and compact.

Short to Medium Telephotos

The 85mm has become known as a "short tele" in 35mm format. Its angle of view, 28°, is noticeably narrower than that of the normal lens's 46°. And wide maximum apertures can still be obtained with this focal length. You can fill the frame with a head and shoulders portrait without moving in too close. This greater "working distance" is useful, as there is little apparent distortion of the subject's nose as is common with a 50mm or wider lens when used for close-ups.

Naturally, the 85mm has other uses; some use it as their standard lens. The AF Nikkor 85mm f/1.8D is a fine choice in a fast,

second lens for the owner of a normal zoom. Its weight is tolerable, and the price manageable.

AF Nikkor 85mm f/1.8 D

AF DC Nikkor 105mm f/2 is one of two Nikkor lenses that allow depth of field to be shifted.

Moving up to 105mm and 135mm, we finally enter the true telephoto range. The AF Nikkor line confirms that these focal lengths in a prime lens are intended for the specialist. The AF-DC Nikkor 105mm f/2 DC and the AF Nikkor 135mm f/2D DC incorporate defocus control. This unique feature allows you to fine tune the depth of field in the foreground or background, increasing blur at any aperture, creating unique effects in portraiture.

Using defocus control requires extensive experimentation as it cannot be judged in the viewfinder. Both of these fast lenses are also well suited to general portraiture but are best used by the creative photographer who demands the ultimate in depth of field control.

ED-IF Lens Technology

Now we reach the cream of the AF Nikkor crop, the professional telephotos, all with two special features: internal focusing (IF) and one or more elements of ED glass to compensate optical aberrations. We don't expect to see many N50/F50 cameras sporting one of these instruments, but all are a credit to Nikon engineering.

With IF, only a few internal elements are moved during focusing. This is preferable to moving the entire optical system which tends to shift the weight of the lens. With an IF system, the center of gravity and the length of the barrel remain constant, a benefit with long lenses. The apparatus is more stable on a tripod, autofocus requires less mechanical effort, and the lens can be made more compact. This type of construction makes close focus correction easier, too, assuring superior results at any distance.

Extra Low Dispersion glass (ED) has become a legend in its own time. All ED telephotos provide extraordinary image quality by compensating for an optical flaw called chromatic aberration. With one or more elements of ED glass, all colors of light are made to focus on a common plane (the film) for maximum sharpness and contrast. This measure is necessary in lenses of long focal length and wide aperture if they are to live up to the highest performance standards possible.

AF Nikkor ED-IF Telephotos

The AF 180mm f/2.8 ED IF is a lens of traditional focal length, becoming less common as zoom lenses take over the market. The advantage of this prime lens over the 80-200mm f/2.8 D ED is size; it's smaller and lighter, and handles beautifully. It is much easier to handhold at shutter speeds of 1/180s or faster for crisp results.

Nikon offers two 300mm AF lenses: the AF Nikkor 300mm f/2.8 ED IF and the AF Nikkor 300mm f/4 ED IF. Scan the prices and the choice becomes obvious, as the first is beyond reach of all but professionals who require an f/2.8 lens for action photography with slow film. The f/4 model is relatively affordable and can still be considered "fast" for a 300mm lens.

Because of its modest weight, this one can be used handheld at 1/500s for sharp results. Unless shooting with fast film, consider using a monopod, attaching the lens with its tripod mounting collar. Like all of the ED telephotos, it has a rear filter drawer which accepts small (inexpensive) 39mm filters. These are inserted in a holder placed at the far end of the light path.

Both AF 300mm ED IF lenses produce outstanding image quality at any aperture and at any distance. The 8° angle of view

results in visible perspective compression, an unavoidable char-acteristic of longer focal lengths. In many cases, however, this is exactly what is required. Such a lens is designed not only for distant subjects but also for shorter ranges where the shallow depth of field can be highly desirable.

Nikkor AF-I Telephotos

Nikon also makes a series of telephoto lenses designated AF-I which contain focusing motors. However, the N50/F50 cannot autofocus with this type and their TC-E teleconverters do not fit other lenses. Therefore, we have decided not to survey these exceptional telephotos in this guide. For additional information we recommend the *Magic Lantern Guide to Nikkor Lenses*, by B. "Moose" Peterson. The author is an acknowledged expert on all Nikon products, having published several books on this topic.

Nikon Filters

The fact that Nikon also offers a wide assortment of filters for their Nikkor lenses is understandable. After all, why produce superior optics when image quality will be degraded by a cheap piece of glass placed in the light path? The principle of the "weakest link" holds true here: any optical system is only as good as the filter used. While it is tempting to buy off-brand filters at bargain base-ment prices, it makes little sense. Once you decide to travel the path of high image quality, don't allow roadblocks to deter you from reaching your goal.

There are other brands of fine filters too, including Tiffen and B+W, but for the purposes of this guide we'll concentrate on the Nikon series. First is the UV filter which helps block ultra violet light which can produce a blue cast. This one is almost clear, so it does not absorb any light or produce a color shift. It is useful for protecting the front element from fingerprints or scratches, so it should remain on the lens at all times. You can safely clean such a filter more often than the sensitive front element and it can be replaced inexpensively when necessary.

Of course, any filter adds two more air-to-glass surfaces,

The effects of a polarizing filter, used on the bottom photo, include deepening the color of the sky and cutting through atmospheric haze to make the image appear sharper.

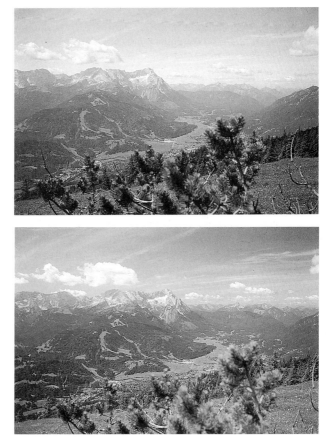

increasing reflection and hence, flare. This is why purists do not agree with leaving a filter on the lens at all times. But when using the multi-coated Nikon L37C filter, flare is less of a concern. Consider this compromise: instead of using the filter selectively, *remove it selectively*. In other words, remove it when shooting in brilliant light, from the side or behind the subject. When flare becomes visible in the viewfinder, shoot without the filter. (Flare resembles a bright veil which reduces sharpness).

The L1BC Skylight filter is similar to the UV filter. It is also multi-coated (for superior light transmission and protection

against flare) and absorbs UV radiation. Because it produces a slight red color shift, it is more useful for counteracting a mild blue color cast in shade, with slide film. However, it is less suitable as a universal filter. Especially when a subject is primarily white, remove the Skylight filter to maintain purity of tone.

To make long exposures possible in bright light, you may need to use a neutral density filter such as Nikon's ND2, ND4 and ND8. The gray glass absorbs some light like sunglasses do. Now you can shoot exposures of several seconds on bright days at wide apertures, perhaps to depict a flowing stream as blurred.

Polarizing Filters

There is one filter which everyone should own, particularly for outdoor photography. It's the polarizer, used primarily for two purposes: to darken a pale blue sky and to remove reflections from glass and water surfaces.

Mount one on a lens and you'll notice it can be rotated within its mount. The filter's position determines its effect. At approximately 90° to the sun, or 35°. to the subject, the effect is the greatest. This can be varied of course, by rotating the external ring or changing your shooting position. The polarizer has practically no effect in back lit situations.

This filter can wipe glare from water, wet foliage or rocks and from any non-metallic surface such as a window pane. Color saturation is increased while affording a clearer view of the subject. The effect is particularly noticeable in sunshine. A blue sky becomes richly dark, while white clouds stand out in bold relief in contrast. Many pleasing travel photos owe their high level of appeal to the polarizer.

The effect depends on the position of the sun and your own position in relation to the subject. If the desired effect cannot be achieved by rotating the ring, change your shooting angle. While it is tempting to strive for maximum polarization, a more subtle effect is often preferable. With water, for instance, removing all of the natural sparkle can produce an artificial, lifeless look.

Objects behind glass can usually only be seen when a polarizer is used to wipe reflections from the surface. Again, the degree of polarization depends on the purpose of the image: leave some mild reflections on a window unless your intentions are purely documentary.

Note: To maintain autofocus and metering accuracy with the N50/F50, a "circular polarizer" must be used. The term "circular" does not describe the shape of the filter, but differentiates it from the conventional "linear" polarizer. If you own the latter, do not use it with this camera. Use only polarizers designated CIR to prevent focusing and metering errors.

While the polarizer is the most versatile filter, it does have one drawback. The gray glass absorbs roughly 1.5 stops of light. So if you're shooting at 1/125s, before adding the filter, this will reduce to 1/45s when the polarizer is mounted. This may be too slow for hand-holding the lens. You might open up to a wider aperture, assuming that is possible (a wider aperture may not be available with your lens) or desirable (as depth of field will be reduced). Otherwise, use a faster film or a firm support for the camera.

Hint: In spite of the reduced light transmission, the N50/F50 will maintain exposure accuracy. Some books and magazine articles suggest that exposure compensation is necessary when using a filter. Ignore such comments. For all practical purposes, they are not relevant when using a camera with through-the-lens metering.

Close-up Photography

As a single lens reflex (SLR) camera, the N50/F50 is well suited for extreme close up photography. Because the viewfinder image is accurate, framing and composition will be accurate as well. What you see is what you get on film, except for the fact that the viewfinder of the N50/F50 shows only 90% of the actual image area. (This topic was discussed in an earlier chapter).

Extreme close-ups, usually referred to as "macro," are most often used for nature photography. These do not concentrate on microscopic-sized insects, but record small sections of a subject or moderately small subjects in their entirety. A dragon fly, covered with dew and clinging to the stem of a weed, or the pistil and stamen of a tulip, are but two examples. Most photo enthusiasts see the world exclusively in terms of large scales, but extreme close up work can open up another dimension.

We literally have to learn to see things in smaller portions. We

Flowers are the most common subject for close-up photography, but there are numerous potential subjects that deserve consideration.

usually ignore tiny details, particularly when we have a camera in our hands. At first, the search for such close-up subjects takes a bit of concentration. The search is easiest with flowers and buds which are among the most popular subjects. But this is really only the beginning! Thousands of other potential subjects are just waiting to be discovered, whether natural or man made.

Note: Traditionally, the term "macro" photography was applied only when the reproduction ratio was at least 1:1, denoting that the subject was reproduced lifesize on the film. Today, the definition is broader, applied to 1/4 lifesize with zooms and 1/2 lifesize with "macro" lenses discussed later.

Accessory Close-up Lenses
These details often lie within the focusing range of today's zoom lenses, particularly those AF Nikkor models with a "macro" des-

ignation. If the close focus distance is 1' (0.3m) or less, the zoom is useful for isolating details such as a large blossom.

For smaller segments, however, you'll need to be able to focus much closer. This can be achieved inexpensively, with a Nikon accessory close-up lens. Resembling a clear filter containing magnifying glass, this device is small, portable and absorbs no light. AF ability is maintained, but you will probably want focus manually in order to set the exact point of focus. This is critical as depth of field is extremely shallow in high magnification work.

Infinity focus is lost because, in effect, you are putting reading glasses on the lens. This is merely academic, of course, as your subject will be inches from the front element. The close focusing distance is reduced depending on the "power" of the accessory lens. These are available from Nikon as 1 and 2, and as 3T, 4T, 5T and 6T versions. The first two are for lenses up to 55mm, while the T-series work best with focal lengths in the 75mm to 300mm range.

The latter are made with two elements (instead of one) and are "achromatic," corrected for optical aberration. The 3T/4T come in a 52mm filter ring, while the 5T/6T in a 62mm ring. With each set, the higher the number, the stronger its effect. Although there are more sophisticated means of achieving extreme close-up effects, the Nikon T-series is used even by professional nature photographers. Optical quality is first rate, especially when used with a Nikkor lens such as the AF 75-300mm f/4.5-5.6. Stop down to f/16 to f/22 for optimum image sharpness from the center to the corners of the frame.

Note: With most other Nikon cameras, "extension tubes" can also be used to reduce the close focusing distance. These are little more than spacers: hollow tubes which move the optical center further from the film plane, allowing for closer focusing. However, as of this writing, Nikon offers only manual focus extension tubes. With the N50/F50 these are not fully "compatible" as discussed earlier.

Macro or "Micro" Lenses
Anyone who becomes a close-up photo enthusiast will eventually want to consider a true macro lens, called "Micro" by Nikon for reasons which remain a mystery. These lenses are superior to a

zoom plus accessory, as they are optimized for extremely close focusing. Close-Range Correction (CRC) is employed so each lens provides consistent quality from infinity to its closest focusing distance.

All three AF Micro Nikkor models allow continuous focusing from infinity to a reproduction ratio of 1:1. This means "life size reproduction": a picture of a penny will be exactly penny-sized on the slide or negative.

The AF Micro Nikkor lenses are renowned for superb optics. These are among the "sharpest" of all lenses, deserving the use of a tripod to exploit their inherent advantages. The first is the AF Micro Nikkor 60mm f/2.8 D which is suitable for copy work, in particular. In such situations, the camera is usually mounted on a stand, extremely close to an inanimate object.

The AF Micro Nikkor 105mm f/2.8D is a short telephoto lens with particularly high performance and continuous focusing to a 1:1 reproduction ratio. Since the working distance is greater with increasing focal length, it is more suited to nature photography. You can fill the frame without moving the lens right up to a tiny blossom, for example.

Insects require an even greater camera-to-subject distance. Move in tight and you run the risk of scaring it off. The extra distance also provides a bit of security for the photographer, particularly if the subject is inclined to sting or bite. And a longer focal length allows you to isolate the subject, excluding much of a distracting background.

This is one reason why we like the new AF Micro Nikkor 200mm f/4D ED IF which is expensive but includes the Distance Signal chip for 3D Matrix metering. Exposure accuracy is increased in extreme close-up work, particularly noticeable when shooting color slides.

But there are other advantages. Internal focusing (moving only a small lens group) improves handling and balance on a tripod; use the mounting collar provided with this heavy lens. ED glass has been incorporated into the optical formula to compensate for chromatic aberration, assuring superb sharpness, color fidelity and contrast. This macro lens is ideal for much nature photography, but the AF Micro Nikkor 200mm f/4ED IF is also a fine general purpose telephoto, although a bit large and hefty for day to day work.

Some of the benefits offered by the AF Micro Nikkor 200mm f/2.8D are incredible sharpness, continuous close focusing, a narrow angle of view and a greater working distance.

Conclusion

If there is one reason why discriminating photographers choose the Nikon system, it is surely the quality of Nikkor optics. Designed by Nikon engineers, and made in their own glass works to the strictest specifications, the Nikkor series is second to none in overall quality. Computerized design, high tech glass, sturdy construction, and a devotion to quality control assure the Nikon reputation for optical excellence.

Naturally, a professional lens will offer superior imaging qualities to a modestly-priced zoom, as we have already admitted. But in terms of consistency of quality for the price, no manufacturer beats Nikon. While several others are definitely competitive, the Nikkor AF series makes the N50/F50 a suitable passport into the world of exceptional image making.

AF Nikkor Lenses for the N50/F50

	Elements/ Groups	Diagonal angle of view	Min. Aperture	Close focu distance (
Zoom Lenses				
20-35mm f/2.8 D	14/11	94°-62°	22	1.7
24-50mm f/3.3-4.5	9/9	84°-46°	22	2
28-70mm f/3.5-4.5 D	8/7	74°-34°20′	22	2
28-85mm f/3.5-4.5	15/11	74°-28°30′	22	3
35-70mm f/2.8 D	15/12	62°-34°20′	22	2
35-70mm f/3.3-4.5 D	8/7	62°-34°20′	22	2
35-80mm f/4-5.6 D	6/6	62°-30°10′	22	2
35-105mm f/3.5-4.5	16/12	62°-23°20′	22	5
35-135mm f/3.5-4.5	15/12	62°-18°	22	5
70-210mm f/4-5.6 D	12/9	34°20′-11°50′	32	5
75-300mm f/4.5-5.6	13/11	31°40′-8°10′	32	10
80-200mm f/2.8 D ED	16/11	30°10′-12°20′	22	6
Fixed Focal Length Lenses				
FE 16mm f/2.8 D	8/5	180°	22	0.85
18mm f/2.8 D	13/10	100°	22	0.85
20mm f/2.8	12/9	94°	22	0.85
24mm f/2.8 D	9/9	84°	22	1.25
28mm f/1.4 D	11/8	74°	16	1.3
28mm f/2.8	5/5	74°	22	1.25
35mm f/2	6/5	62°	22	0.85
50mm f/1.4	7/6	46°	16	1.5
50mm f/1.8	6/5	46°	22	1.5
85mm f/1.8 D	6/6	28°30′	16	3
DC 105mm f/2 D	6/6	23°	16	3
DC 135mm f/2	7/6	18°	16	4
180mm f/2.8 IF-ED	8/6	13°40′	22	5
300mm f/2.8 IF-ED	8/6	8°10′	22	10
300mm f/4 IF-ED	8/6	8°10′	32	9
Macro Lenses				
60mm f/2.8 D	8/7	39°40′	32	0.815
105mm f/2.8 D	9/8	23°20′	32	1
200mm f/4 D IF-ED	13/8	12°20′	32	2

Min. Macro setting (ft)	Filter diameter (mm)	Lens hood	Length (inches)	Max. diameter (inches)	Weight (g)/oz.
	77	HB-8	3.7	3.2	640/22.4
1.6	62	HB-3	2.9	2.8	375/13.1
1.3	52	HB-6	2.8	2.7	355/12.4
0.8	62	HB-1	3.5	2.8	540/18.9
0.9	62	HB-1	3.7	2.8	675/23.6
1.1	52	HN-2	2.2	2.6	241/8.4
1.1	52	HN-2	2.4	2.6	255/8.9
0.9	52	HB-5	3.4	2.8	510/17.9
	62	HB-1	4.3	2.9	685/24.0
3.9	62	HN-24	4.3	2.9	590/20.7
5	62	HN-24	6.5	2.8	850/29.8
4.9	77	HB-7	7.4	3.4	1300/45.5
	Bayonet	Built-in	2.2	2.5	285/10.0
	77		2.2	3.2	385/13.4
	62	HB-4	1.7	2.7	260/9.1
	52	HN-1	1.8	2.5	260/9.1
	72	HK-7	3.1	3.0	520/18.2
	52	HN-2	1.5	2.5	195/6.8
	52	HN-3	1.7	2.5	215/7.5
	52	HR-2	1.7	2.5	255/8.9
	52	HR-2	1.5	2.5	156/5.5
	62	HN-23	2.3	2.8	415/14.5
	72	Built-in	4.1	3.1	620/21.7
	72	Built-in	4.7	3.1	870/30.5
	72	Built-in	5.7	3.1	750/26.2
	Bayonet	Built-in	9.5	4.9	2700/94.5
	Bayonet	Built-in	8.6	3.5	1330/46.6
	62	HN-22	2.9	2.8	455/15.9
	52	HS-7	3.3	2.6	555/19.4
	62		7.6	3.0	1200/42.0

Great Pictures with Your N50/F50

With the sophisticated N50/F50, most anyone can produce sharply focused pictures with correct exposure. Autofocus, Advanced Matrix metering, and Program modes make it easy to take technically "perfect" pictures. This is an impressive achievement, except for one fact: a technically perfect picture may have little viewer appeal.

The finest paint brush, most expensive canvas and the most brilliant paints in the world won't make you an "old master". You will have to develop a feel for the brush strokes, the play of light and shadow, the use of perspective and relative size. More importantly, you'll need an appreciation for the difference between the "real world" image your eyes perceive, and that which can be recorded on a flat material.

Although there are dozens of techniques for creating pictures with high visual appeal, the following have proven successful for many people first making the transition to an SLR camera.

Develop an Awareness for Light

Too many people with a camera find everything photogenic. They walk around snapping pictures indiscriminately until the film runs out. What some fail to notice is the direction of light in relation to the subject. And yet, the direction of incident light determines the impact the subject will make on a subsequent viewer.

If the sun is behind you, the frontal light produces a flat image. This occurs because shadows fall behind objects and become nearly invisible in a photo. The colors may be vibrant and the negative easy to print because of low contrast, but the picture may lack an important dimension.

When the sun is to the side, shadows become readily visible. This interplay between light and shadow - contrast - can help to simulate depth. Viewers can identify several planes. They also see contours instead of a flat "cardboard cut-outs" masquerading as a subject. So try to use sidelighting when possible, to create "modeling," which can add a three-dimensional feel to your pictures.

The interplay between light and shadow can make fascinating photographs.

Backlight creates magic. You may have to shade the lens (to prevent flare) when shooting into the light, but this is worth the effort. The atmosphere of the image will be far more striking than in front lighting. Large dark areas bring tranquillity into the picture. Dust, mist and smoke in the atmosphere create wonderfully appealing moods. Light passes through semi-transparent forms such as foliage. Shadows fall directly towards the viewer. The contrast between light and dark is very high and dramatic in many cases. (If you find the contrast excessive, use flash with the N50/F50).

Unless you're shooting land or cityscapes, it is often possible to move the subject into a different position. Or wait until later in the day, when the low sun creates a warm side or backlight which will complement the subject. This is all part of controlling the process introduced in previous chapters. It's another step to creating images instead of merely shooting whenever it's convenient.

Fill the Frame

"If your pictures aren't good enough, you're not close enough". Wise words from WW II photo journalist Robert Capa and probably the most useful advice we can pass on. If you cannot walk up to the subject, switch to a longer lens. When the situation presents vertical lines, rotate the camera to avoid wasted space at the edges of the frame. Otherwise, ask the lab to crop the enlargement or use scissors yourself afterwards. If framing the picture, order a custom-cut matte with an opening just the right size to show only the desired section of the print.

Naturally, not every situation benefits from tight framing. A photo essay of a blacksmith, for example, calls for including the anvil and forge in some of the frames. And a triathalon cyclist needs space to move into. But there's rarely any need to include the cars parked along the road beside her.

Strive to present a clear message to the viewer by excluding any superfluous elements. Simplify your pictures from a high or low viewpoint if necessary. No matter what type of photography you enjoy, greater reliance on close-ups should help to increase the visual impact of your pictures.

Try New Focal Lengths

While a few photographers have produced an exceptional body of work with a limited range of focal lengths, the vast majority demand greater versatility. If you have been shooting with the AF 35-80mm Nikkor zoom, consider the possibilities of a 28mm wide angle as a start.

Notice how the foreground becomes more prominent while distant subjects are recorded as smaller than the naked eye perceives. Move in close to emphasize a group of wildlfowers and include an expansive sweep of blossoms (at f/22) behind it. With

The center of interest shouldn't necessarily be in the center of the frame. ▷ **This photo of an umbrella is interesting because it uses diagonal lines to lead the viewer's eye to the off-center subject.**

shorter focal lengths, depth of field is greater at any aperture. Set focus roughly a third of the way into the scene to maximize the range of acceptable sharpness.

Or switch to the 75-300mm Nikkor and zoom out to a full 300mm. At a zoo, make impressive wildlife portraits, instead of duplicating the snapshots of others with a 50mm lens. Capture the intensity of a high school quarterback's expression from the sidelines. Use the narrow angle of view to eliminate a dull sky or secondary subjects which compete for the viewer's attention.

Take advantage of the shallow depth of field, rendering one or two blossoms sharply against a soft, posterlike backdrop of an identical color. Again, the possibilities are endless, limited only by your imagination and choice of subject matter.

Select the Best Viewpoint

Frankly, most hobby photographers pay too little attention to camera position and angle of view. They notice something of interest, aim and fire - from wherever they happen to be standing and with whatever focal length is set.

Shooting from eye level is certainly comfortable. But if every picture is taken from the same height, monotony soon sets in when viewing a slide show or album. Especially with very tall and very short people, the results can be less than pleasing. In outdoor photography, burn some calories to find different viewpoints. Climb a tree or rock, or get down and dirty until you find the best vantage point for the particular subject.

Look for dynamic diagonals, often determined exclusively by the position of the camera. Instead of facing the storefronts in a Western town, create a diagonal composition from another angle. When working with a wide angle lens, try pointing the camera upward among a stand of trees. Shoot from ground level and the vertical lines will converge, becoming diagonals. In both examples, these will help to add a feeling of depth to the image, to simulate that missing third dimension.

Rather than using a "full-frontal" approach to recording every subject, seek out a variety of vantage points. Try using compositional elements, such as diagonal lines and negative/positive space to engage the viewer.

Compare these two pictures, analyzing the subtle differences: the location of the lamp post, the position of the camera, and details which have been included or cropped out. Learn to evaluate your photographs the same way before pressing the shutter release button.

Add a Secondary Element

We have all seen pictures of the most majestic mountains which were flat and unimpressive in a print or slide. When viewing an image of distant subjects, without anything to add a sense of scale or reference point, the viewer is rarely satisfied.

A secondary subject in the foreground can improve the photograph instantly. Now, the eye finds a reference from which to evaluate the distance to the background or its likely size. And suddenly that flat, two dimensional scene achieves depth. With the most successful pictures, one almost feels as if he were viewing the landscape through a window. This is exactly the effect you should strive to achieve.

Naturally, a foreground element is not always immediately available. You may well need to walk to another position until a rustic building, a clump of bushes, hikers, or a pond presents itself. If you decide to frame the scene with overhanging branches, select a wide aperture (such as f/4) and move in close to blur them away completely. When the framing element is distant, set a very small aperture (like f/22) to keep it from being partially blurred, a distracting effect. Decisive tactics of this type make for stronger pictures than the wishy-washy f/8 selected by "AUTO" Program mode.

When shooting outdoors, look also for a lead-in line such as a path stretching toward the subject, or the graceful S-curve of a river in the mid-ground. Or seek out an area of contrasting color, texture or shape. No matter how intelligent, the N50/F50 has yet to master these essential aspects of creative image making. Even in this high-tech era, the photographer remains responsible for finding and organizing the picture elements.

All of the suggestions mentioned here are actually compositional devices. Although we have intentionally avoided a long treatise on the Rules of Composition, these tactics have proven successful in increasing the visual appeal of many outdoor and travel photographs.

Strive for Visual Impact

Watch someone browsing through a book full of pictures and one fact will become apparent. Today's viewer is quick to evaluate the impact of an illustration, flipping past those which fail to capture his attention. Unless it evokes some emotion, or offers a powerful visual statement, it will hold his interest for only a couple of seconds.

After achieving technical excellence with the N50/F50, challenge yourself to control the situation. Photograph children from their own eye level, tripping the shutter at the instant of a fleeting expression. Strive for eye contact in some portraits for a sense of intimacy. Use a long shutter speed to depict fluid motion at a high jump competition. Produce an impression of speed by panning with a skater on a frozen pond, streaking the background trees.

171

Wide-angle lenses produce images with an "expanded spatial perspective". In combination with dominant foreground subjects and a diagonal "lead-in" line, a photograph with a three dimensional feel is produced.

Whatever the subject, find a suitable technique which will help reinforce the theme for the viewer. Reading books or magazines dealing with photographic methods can help with that "shortcut to great pictures" promised by Nikon.

Conclusion

The assessment of any picture as "good", "bad", "dynamic" or "boring" is a highly subjective judgement. However, unless you shoot strictly for yourself, keep the interests of subsequent viewers in mind. Study fine art or the work of famous photographers in books at your Public Library and analyze what made them successful.

While imitation will not create unique pictures, get some inspiration from viewing the best work of others and reading about how it was achieved. Then go on to develop your own strategies for effective communication. These will help you get the maximum pleasure from your N50/F50 and maximize the potential of the exceptional AF Nikkor lenses.

From Silver Pixel Press

Wildlife Photography: Getting Started in the Field

By B. Moose Peterson

With the underlying idea of protecting the subject and its habitat, this book covers a variety of situations, including shooting in the field and your backyard, nocturnal photography, and photographing nesting birds and captive subjects. Practical advice on how to optimize results through research, how to approach and attract wildlife. Peterson's tips on working with biologists and wildlife rehabilitation experts can open doors to unique photographic opportunities. Over 125 color illustrations. Softbound. 8-1/2 x 11". 152 pp. ISBN 1-883403-27-8

Nikon Guide to Wildlife Photography

By B. Moose Peterson

Ever wonder how pros capture the stunning wildlife photos you see in magazines? Learn the secrets of a successful wildlife researcher and accomplished photographer. Includes equipment and techniques, plus Peterson's stunning color photographs. Written in a conversational style with many field tips. Over 140 color photographs. Softbound. 8-1/2 x 11". 176 pp. ISBN 1-883403-06-5

Magic Lantern Guides

....take you beyond the camera's instruction manual.

The world's most popular camera guides; available for most popular cameras

Nikon System Handbook, 4th Edition

By B. Moose Peterson

The recognized authoritative text on the Nikon SLR system, this book covers the entire SLR line from the 1959 introduction to the present, including the new F5. Completely revised and updated, this edition includes everything from early equipment and rare items to the latest camera bodies and AF-I lenses. Every body, lens, flash, and accessory from Nikon is described in detail from a photographer's point of view. Over 130 duotone illustrations. Softbound. 7-1/2 x 10". 176 pp. ISBN 1-883403-32-4

From Hove Books!